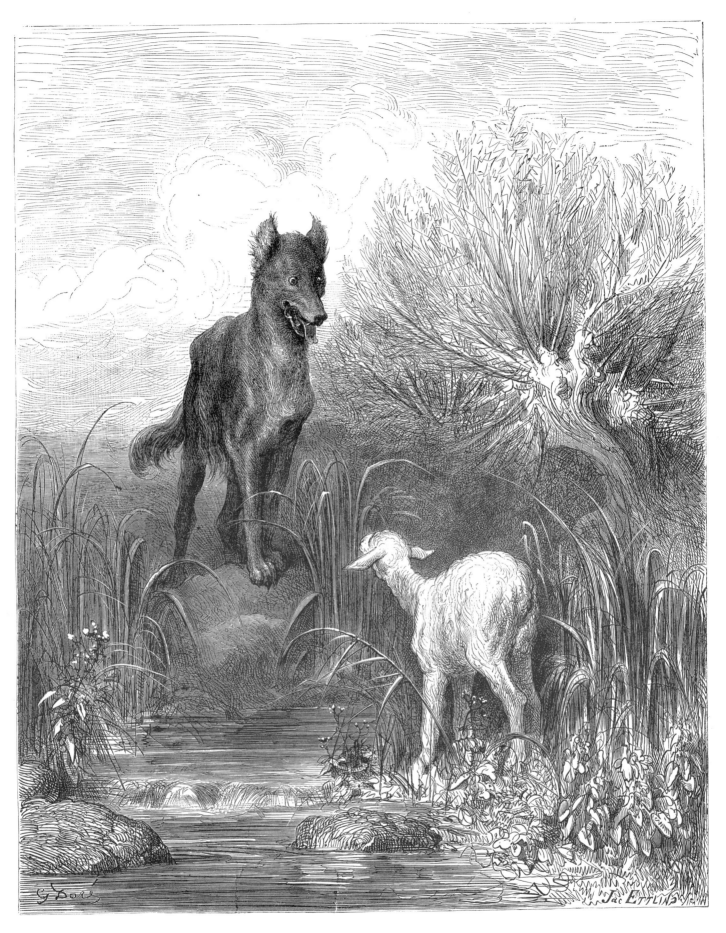

THE WOLF AND THE LAMB
[Le Loup et L'Agneau]

The gentle lamb attempts to reason, in vain, with the ferocious wolf.

DORÉ'S ILLUSTRATIONS
FOR THE
FABLES OF LA FONTAINE

GUSTAVE DORÉ

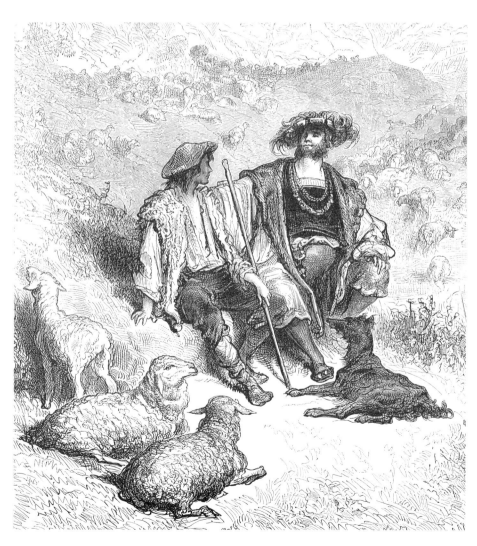

DOVER PUBLICATIONS, INC.
Mineola, New York

Bibliographical Note

This Dover edition, first published in 2003, contains all 84 full-page plates, and a selection of 39 vignettes, from the work originally published as *Fables de la Fontaine avec les Dessins de Gustave Doré* by Librairie de L. Hachette, Paris, in 1868. The Publisher's Note and captions were prepared specially for the present edition.

DOVER *Pictorial Archive* SERIES

Library of Congress Cataloging-in-Publication Data

Doré, Gustave, 1832-1883.
 Doré's illustrations for the Fables of La Fontaine / Gustave Doré.
 p. cm. — (Dover pictorial archive series)
 "Dover edition, first published in 2003, contains all 84 full-page plates, and a selection of 39 vignettes, from the work originally published as Fables de la Fontaine avec les dessins de Gustave Doré by Librairie de L. Hachette, Paris in 1868."
 ISBN 0-486-42977-6 (pbk.)
 1. Doré, Gustave, 1832-1883—Themes, motives. 2. La Fontaine, Jean de, 1621-1695. Fables—Illustrations. 3. Fables, French—Illustrations. I. Title: Illustrations for the Fables of La Fontaine. II. Title: Fables of La Fontaine. III. La Fontaine, Jean de, 1621-1695. Fables. IV. Title. V. Series.

NE650.D646A4 2003
741.6'4'092—dc21

2003048972

Manufactured in the United States of America
Dover Publications, Inc., 31 East 2nd Street, Mineola, N.Y. 11501

Publisher's Note

The French poet Jean de La Fontaine (1621–1695) held positions in civil service but was keenly interested in gaining financial support so that he could devote himself to writing. He did so by ingratiating himself with wealthy patrons in Paris. His chief work, the *Fables*, is a collection of inspired retellings of tales derived mainly from the Aesopic tradition. La Fontaine's verses evoke the wisdom and foibles of both man and beast, as well as the importance of various political matters pertaining to France in the late seventeenth century. (Some of the poet's verses, in fact, are dedicated to members of the French court.) In many of the tales, Greek gods and goddesses appear to instruct and punish. In others, moral dilemmas are dissected and resolved as La Fontaine dispatches the foolish with his barbed commentary. Lessons are learned both apart from the bustle of daily life (advice given by a hermit), and in the midst of it (the workings of the marketplace). The publishing history of La Fontaine's *Fables* is as follows: The first collection of the fables [Books I–VI] was published in 1668; Books VII through XI appeared in 1678 and 1679; and a final collection, Book XII, was brought out between 1692 and 1694. All twelve books were reproduced in the 1868 Hachette edition used for this Dover edition.

Gustave Doré, luminary of nineteenth-century illustration, was born in Strasbourg, France, in 1832. Despite his father's insistence that he pursue a conventional education, the youth embraced art as his chosen means of expression. He gained popularity at the age of fifteen with his contribution of caricatures to the publication *Le Journal pour rire*. After his father's death, Doré supported his family by producing a variety of works, including travel books and illustrated journalistic pieces. He enjoyed great success, both in reputation and fortune, in the 1850s. In 1854, with the publication of an illustrated version of Rabelais's *Gargantua and Pantagruel,* Doré began to focus his considerable energies on a spectacular goal—that of illustrating the world's classic literature. Among his masterworks are his *Don Quixote* (1863), *Bible* (1866), *Paradise Lost* (1866), *Divine Comedy* (1868), *Rime of the Ancient Mariner* (1875), and *Orlando Furioso* (1879). Although he was extremely prolific, the artist chose to entrust much of the actual work to a cadre of engravers (their names appear in the lower right-hand corner of the full-page plates in this edition of La Fontaine's *Fables*). The extent of Gustave Doré's output includes over 200 illustrated books, 100 paintings, and thousands of spot illustrations; he took up sculpting in his later life as well. He died in 1883.

The illustrations in the present volume are taken from *Fables de la Fontaine avec les Dessins de Gustave Doré*, first published by Librairie de L. Hachette, Paris, in 1868. All 84 full-page plates are reproduced here in their original sequence, with the exception of the plate used as the Frontispiece on page ii. Captions have been specially prepared for the full-page plates in this Dover edition; they are based on the story line of the original French text. The French title of the fable appears below the English title. A group of 39 vignettes, selected from the original fable headpieces, follow the full-page illustrations. Captions indicate the titles of the fables for which the headpieces were done.

List of Full-Page Illustrations

List of Vignettes

Doré's Illustrations for the Fables of La Fontaine

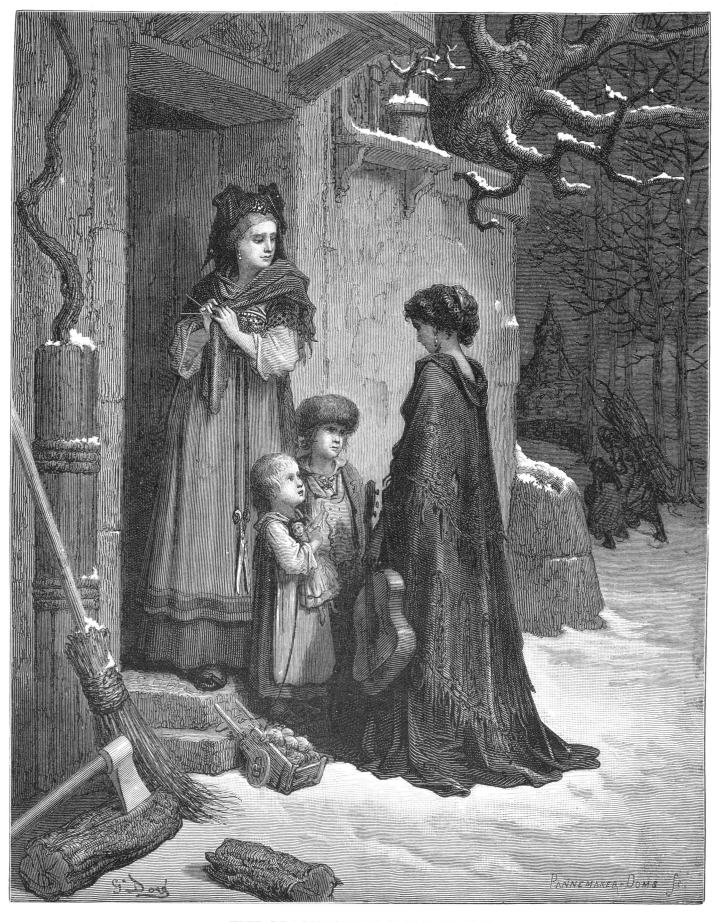

THE GRASSHOPPER AND THE ANT
[La Cigale et la Fourmi]

Like the grasshopper, the woman whiled away the summer when she ought to have been
planning ahead, and she faced poverty when winter arrived.

1

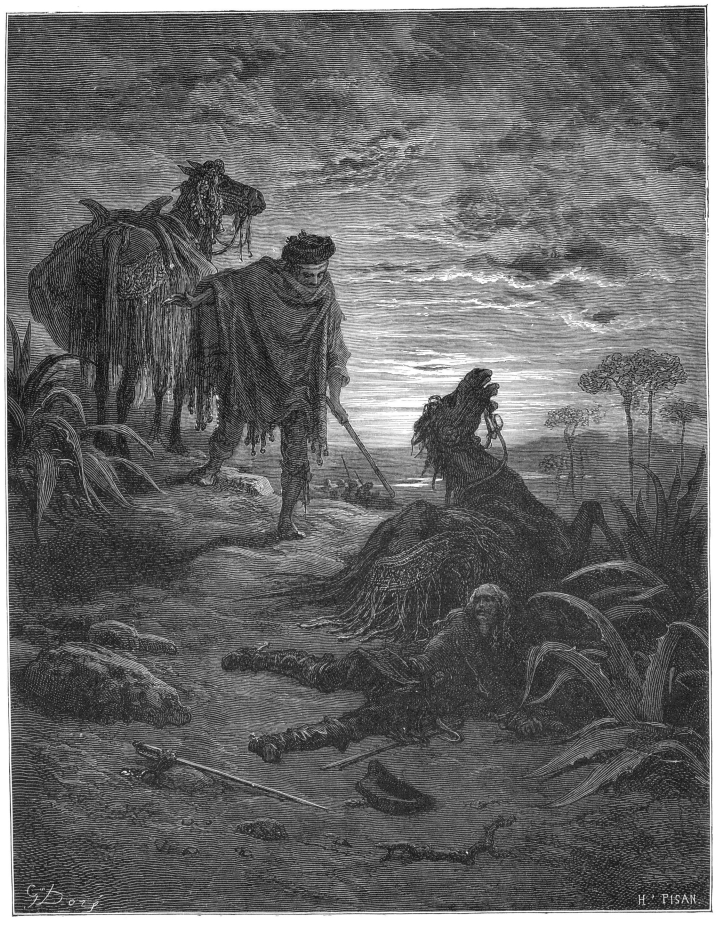

THE TWO MULES
[Les Deux Mulets]

The beast that made a show of its wealth attracted unwanted attention and paid a severe price.

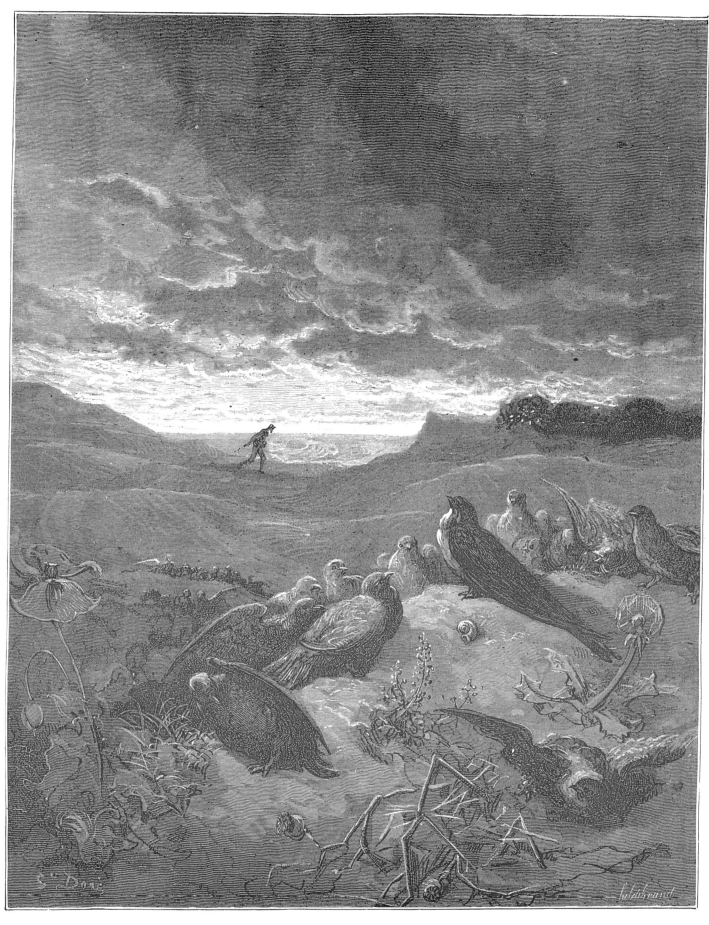

THE SWALLOW AND THE LITTLE BIRDS
[L'Hirondelle et les Petits Oiseaux]

Despite the swallow's warnings, the heedless birds missed their opportunities to escape.

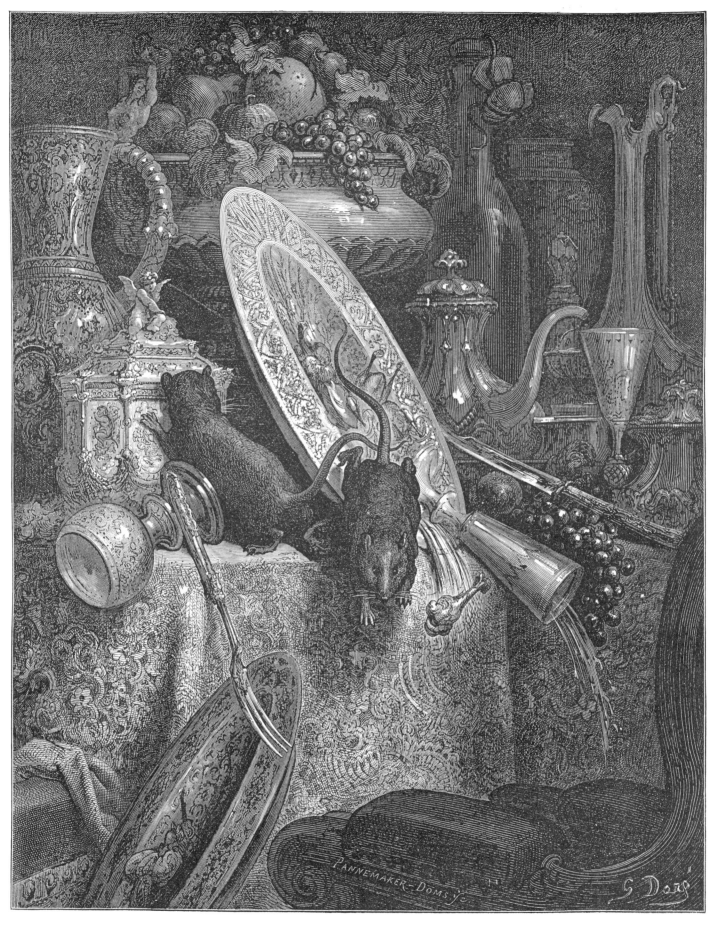

THE CITY RAT AND THE COUNTRY RAT
[Le Rat de Ville et le Rat des Champs]

The country rat will forgo the luxuries of its city cousin,
preferring the security of its modest home.

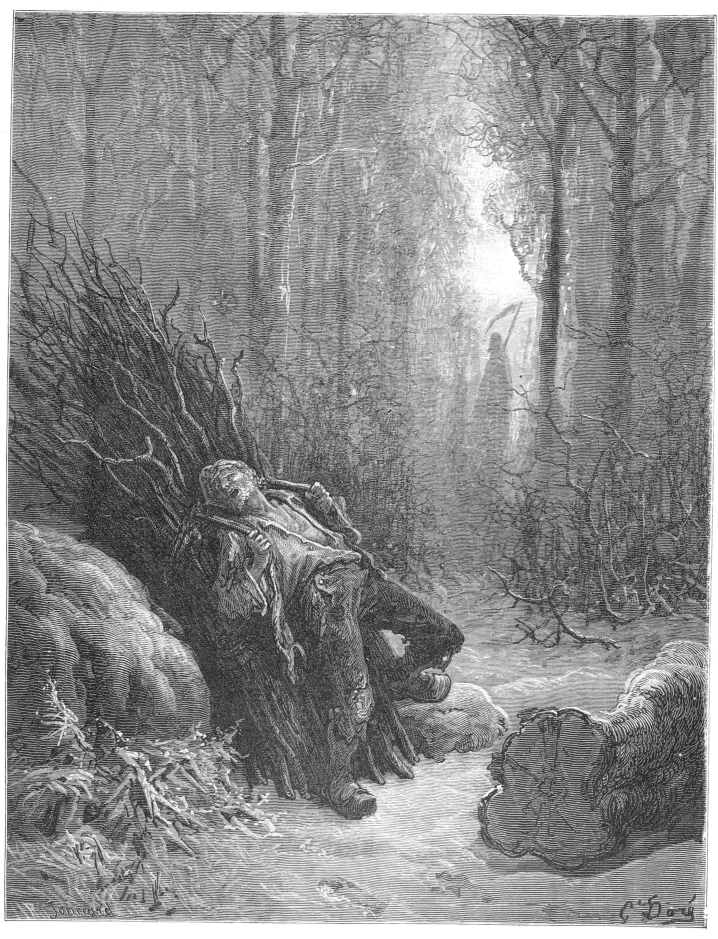

DEATH AND THE WOODCUTTER
[La Mort et la Bûcheron]

The despairing woodcutter, crushed by his burdens, invites Death to end his misery.

THE OAK AND THE REED
[Le Chêne et le Roseau]

The slight reed is better able to withstand the fierce storm than the sturdy, but inflexible, oak.

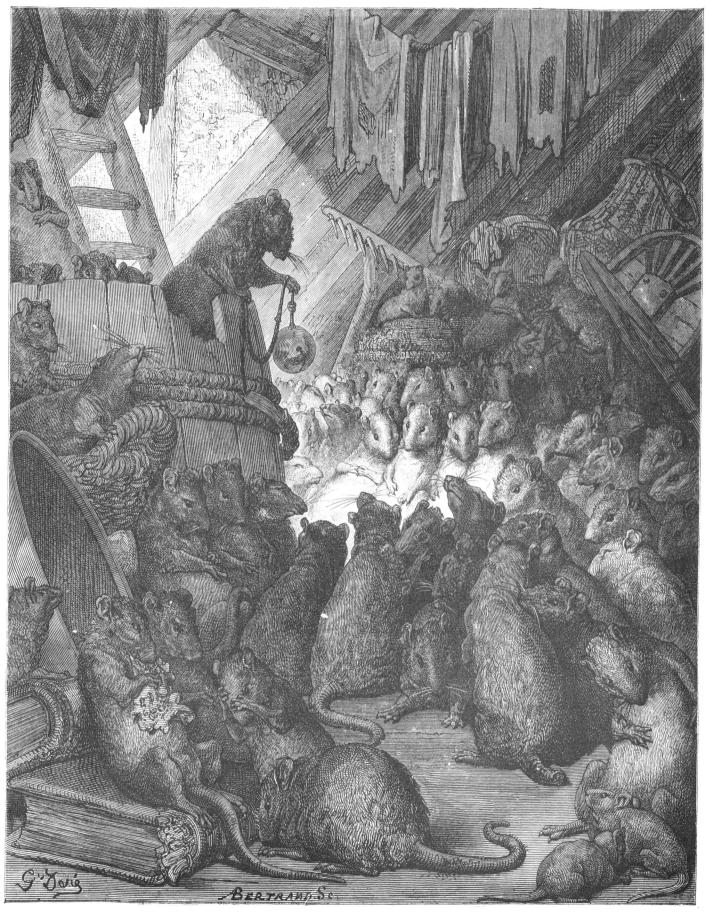

THE COUNCIL HELD BY THE RATS
[Conseil Tenu par les Rats]

The grand idea offered at the council of the rats will come to nothing
if there is no one to carry it out.

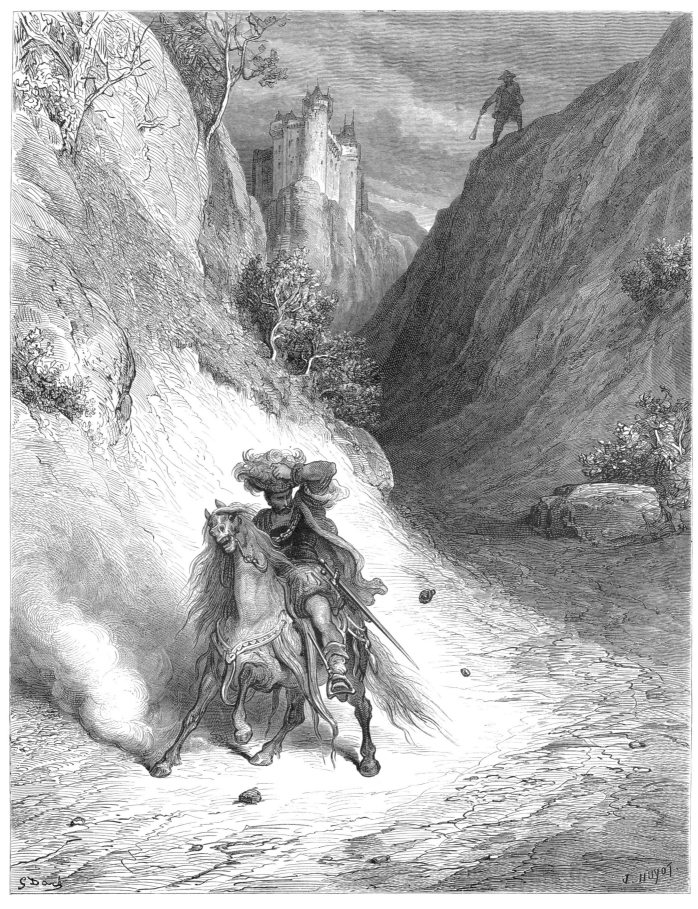

THE LION AND THE GNAT
[Le Lion et le Moucheron]

Just as the gnat conquered the mighty lion with its pesky bite,
small acts may menace us.

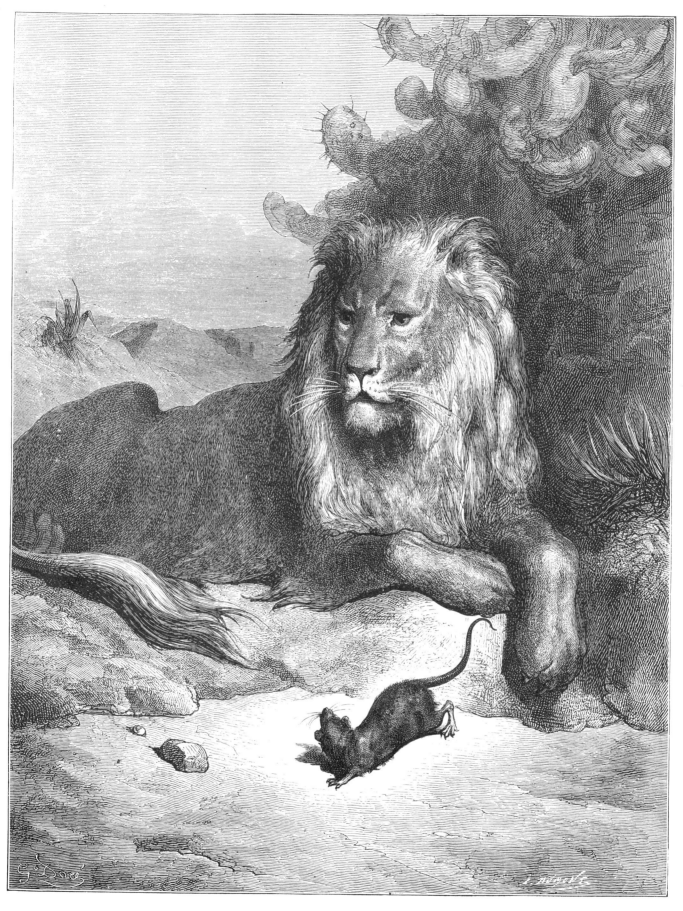

THE LION AND THE RAT
[Le Lion et le Rat]

The lion's restraint brought it a friend who one day would return the favor.

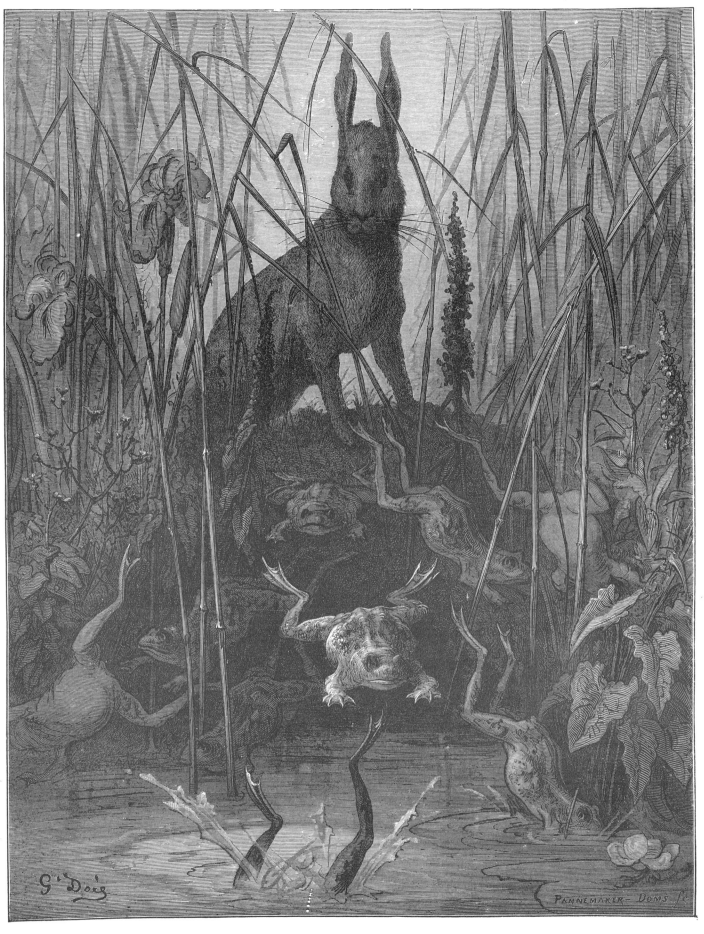

THE HARE AND THE FROGS
[Le Lièvre et les Grenouilles]

The hare's own fears diminished when it came upon the frogs, who reacted in terror.

THE PEACOCK COMPLAINS TO JUNO
[Le Paon Se Plaignant à Junon]

In spite of its gorgeous plumage, the peacock envied the plain nightingale its glorious song.

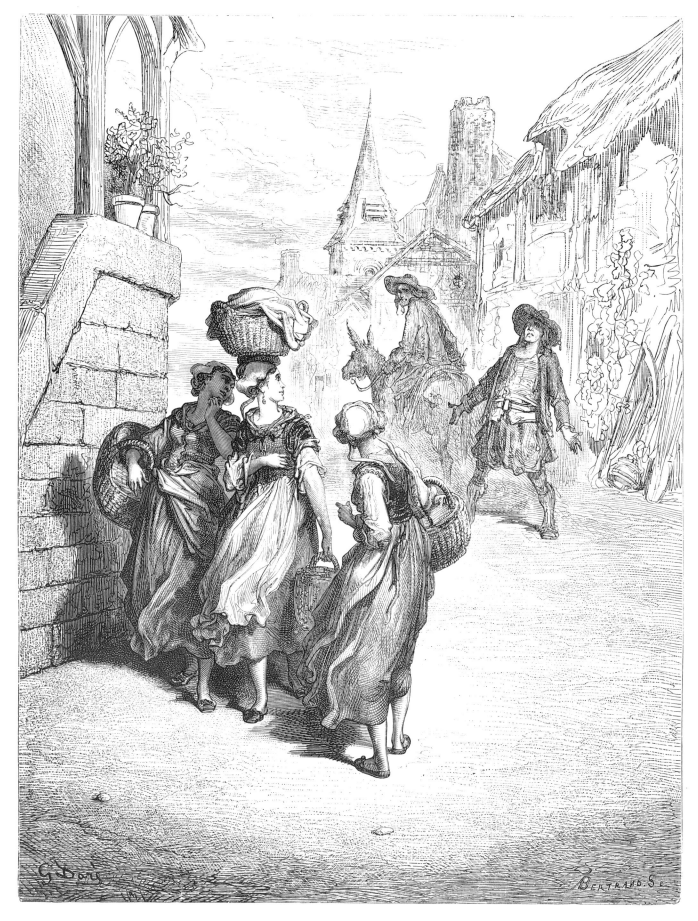

THE MILLER, HIS SON, AND THE ASS
[Le Meunier, Son Fils, et l'Ane]

The merchants thought the father wrong to let his son ride the ass;
the young women thought the father wrong to make the boy walk.

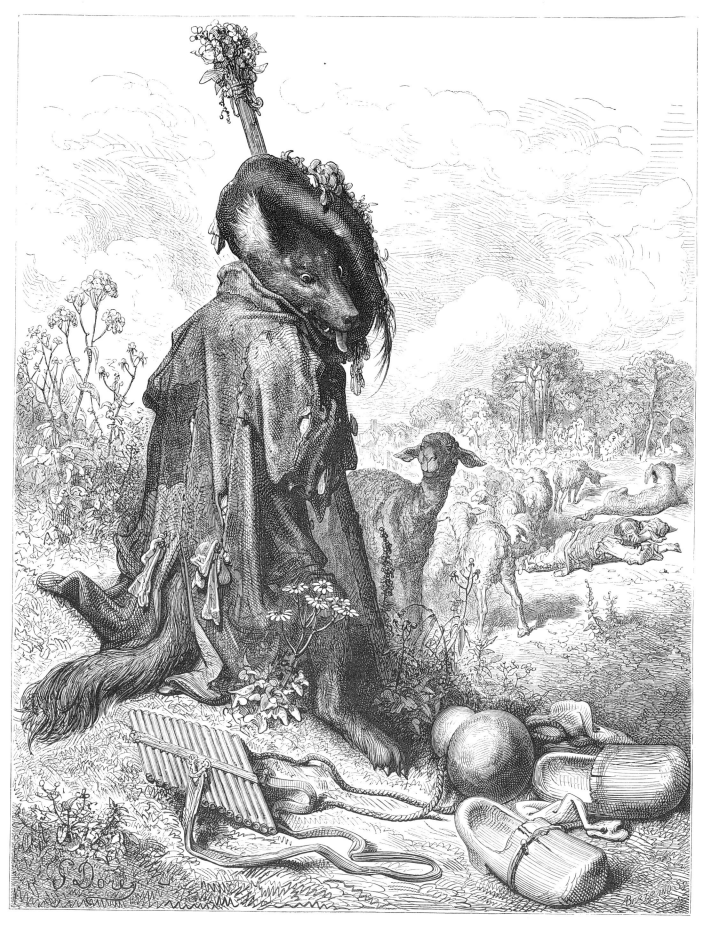

THE WOLF WHO BECAME A SHEPHERD
[Le Loup Devenu Berger]

The wolf fooled the sheep with his costume, but he was recognized when he spoke.

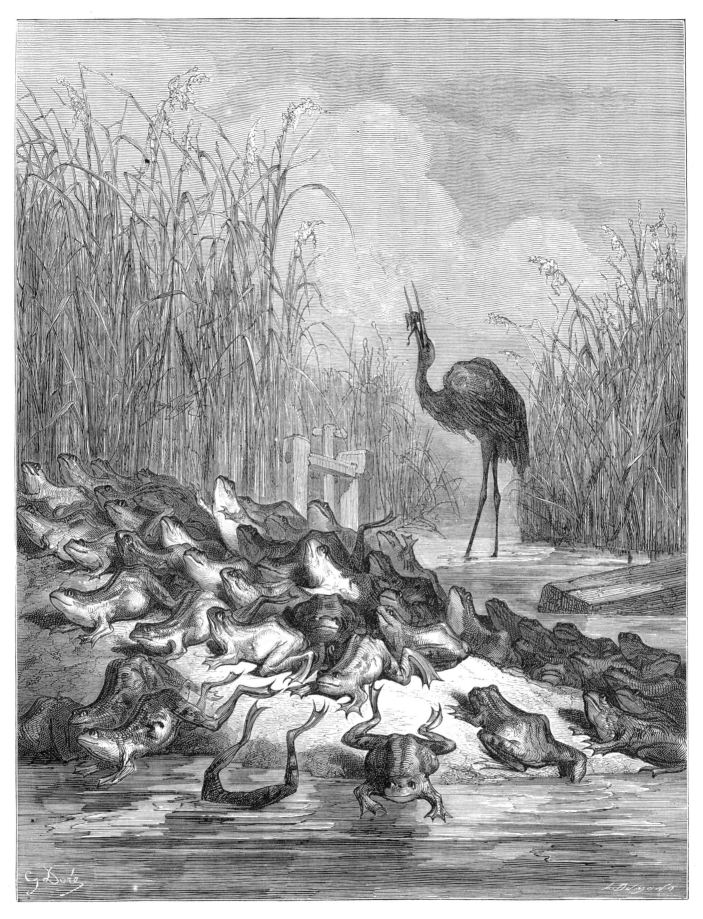

THE FROGS WHO ASKED FOR A KING
[Les Grenouilles Qui Demandent un Roi]

The frogs complained when they received a log as king,
but then they were sent a crane—their enemy.

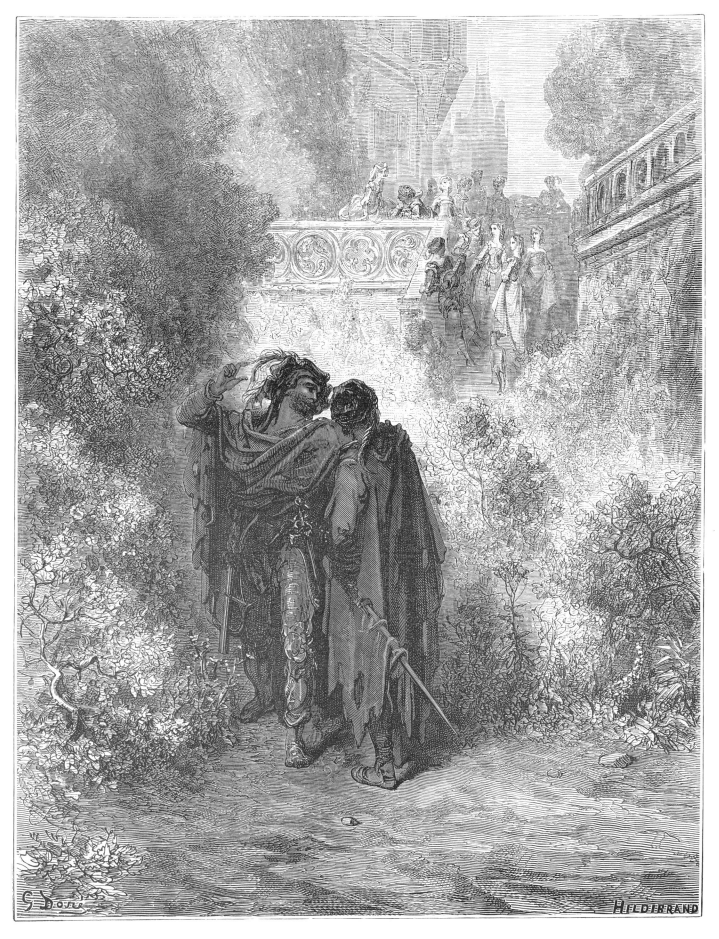

THE FOX AND THE GRAPES
[Le Renard et les Raisins]

The fox, unable to reach the grapes, decided that they were not worth the effort.
Similarly, the courtiers dismissed what they could not obtain.

15

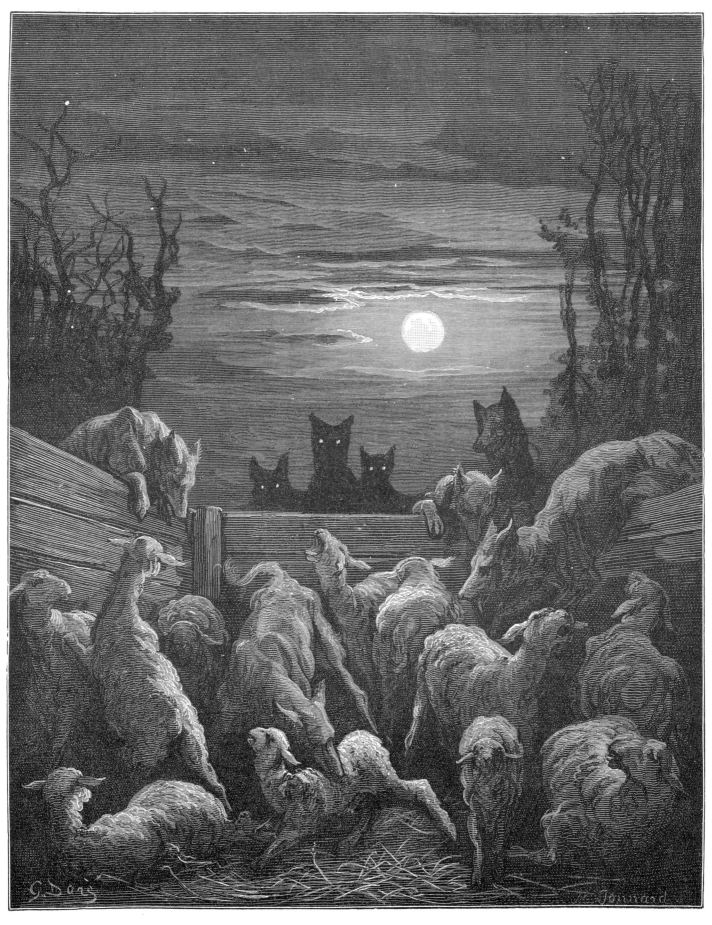

THE WOLVES AND THE FLOCK OF SHEEP
[Les Loups et les Brebis]

The wolves made a treaty with the sheep, but they were wolves, after all, and slew the flock.

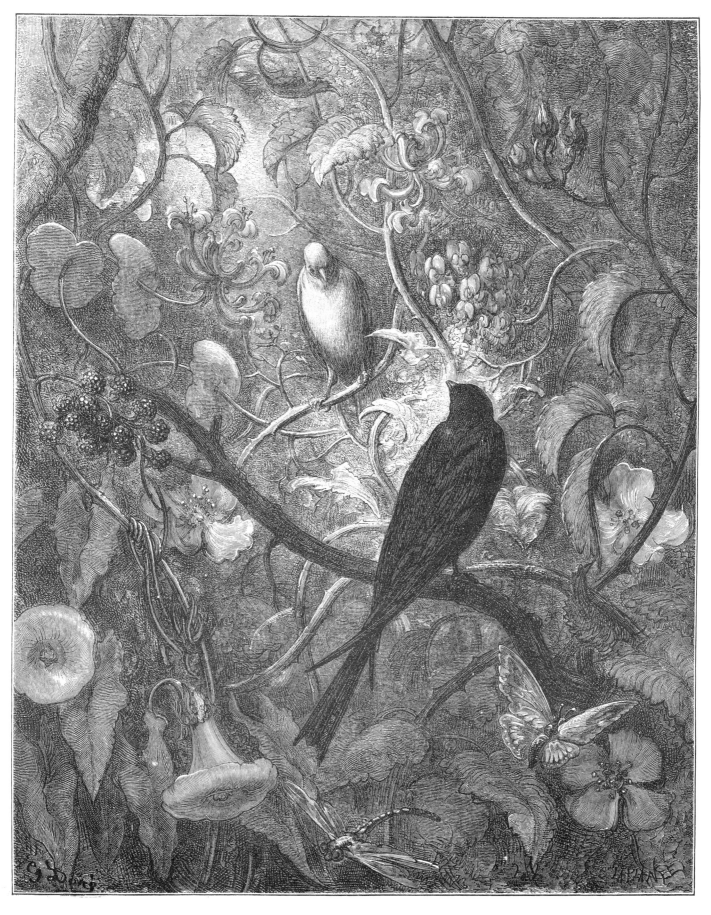

PHILOMEL AND PROGNE
[Philomel et Progné]

Progné entreats Philomel to leave the solitude of the woods for the cities,
but Philomel wants to remain alone with her grief.

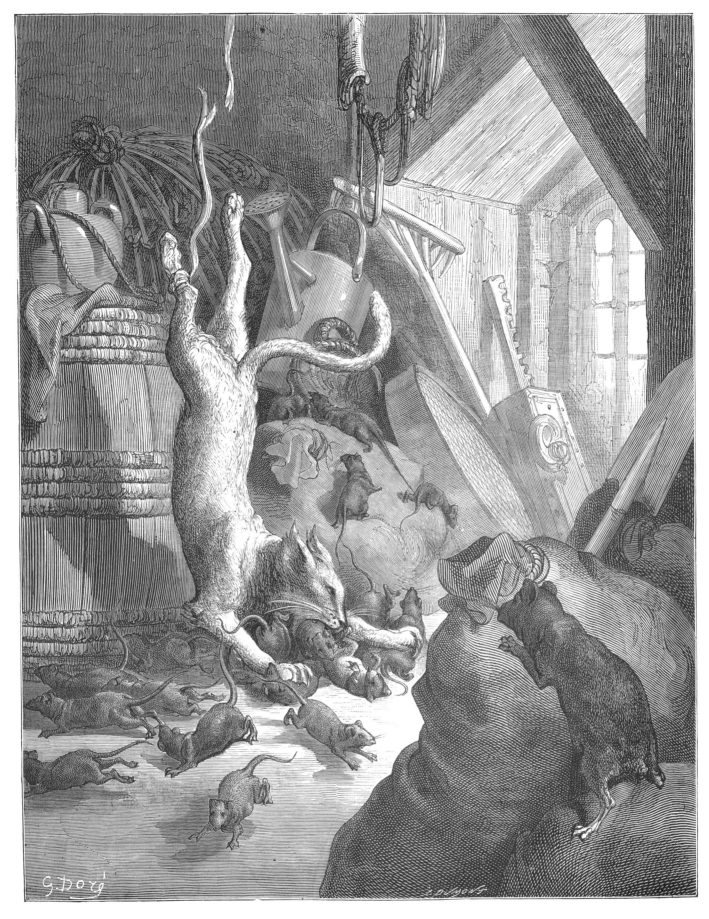

THE CAT AND THE OLD RAT
[Le Chat et le Vieux Rat]

Many were tricked by the cat's ruses, but the wise old rat was suspicious, and thus saved his life.

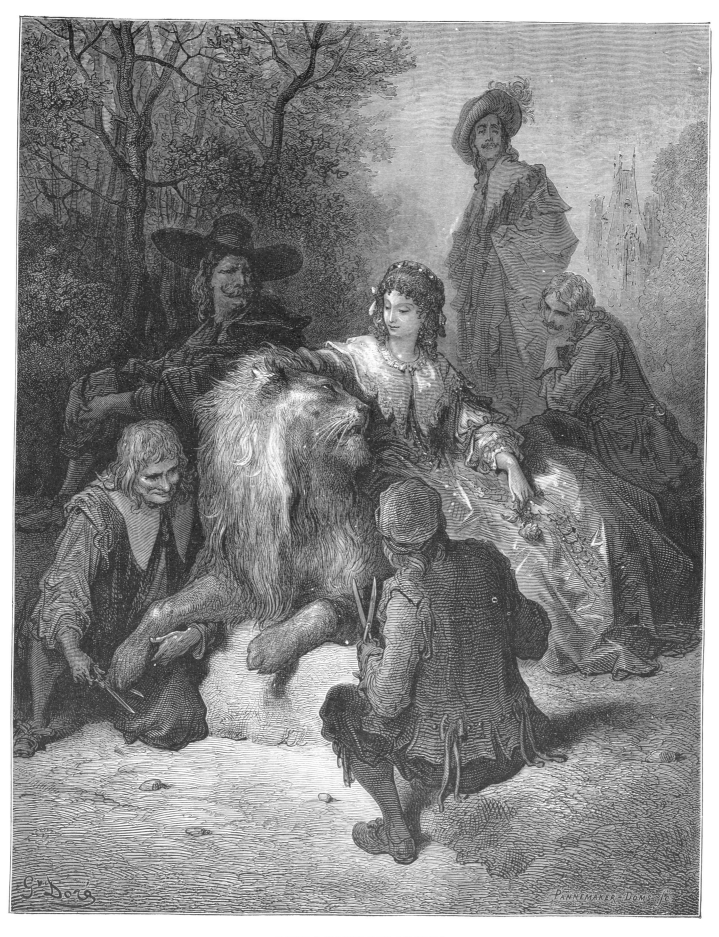

THE LOVELORN LION
[Le Lion Amoureux]

The mighty lion, blinded by love, gave up his defenses and was swiftly slaughtered.

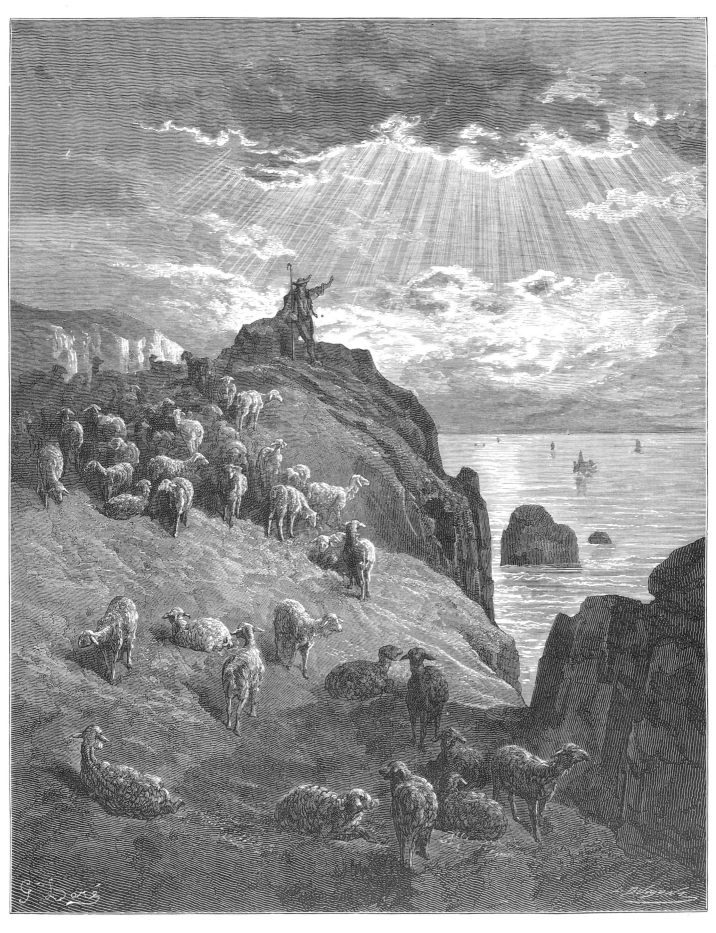

THE SHEPHERD AND THE SEA
[Le Berger et la Mer]

The shepherd, tempted by the sea, made a fortune and lost it; he gladly returned to his flocks.

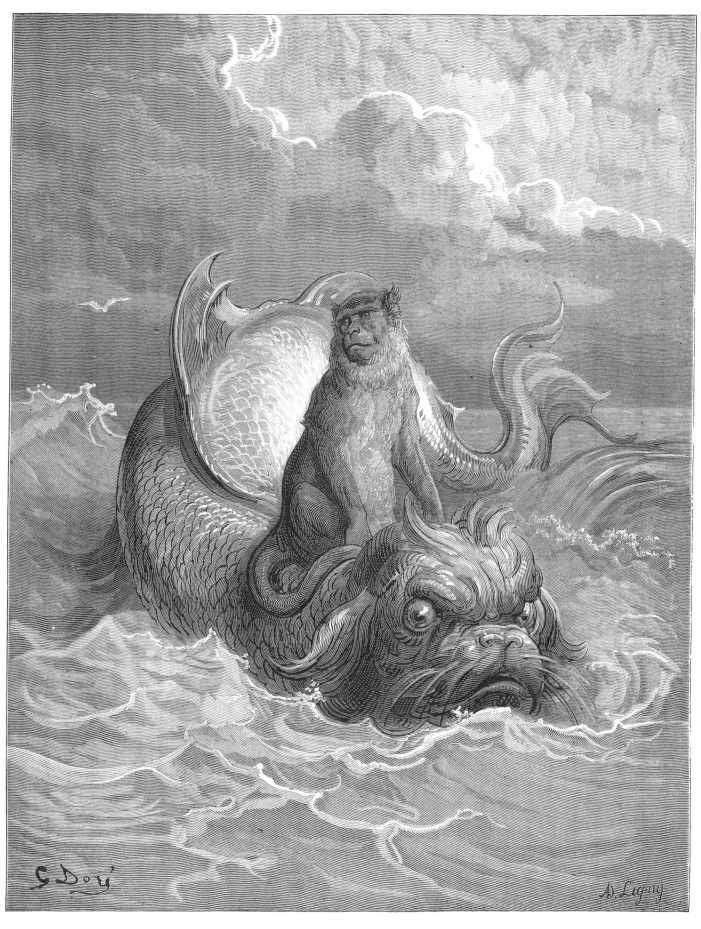

THE MONKEY AND THE DOLPHIN
[Le Singe et le Dauphin]

The dolphin thought it was saving a sailor, but was dismayed to find it was carrying a chattering fool.

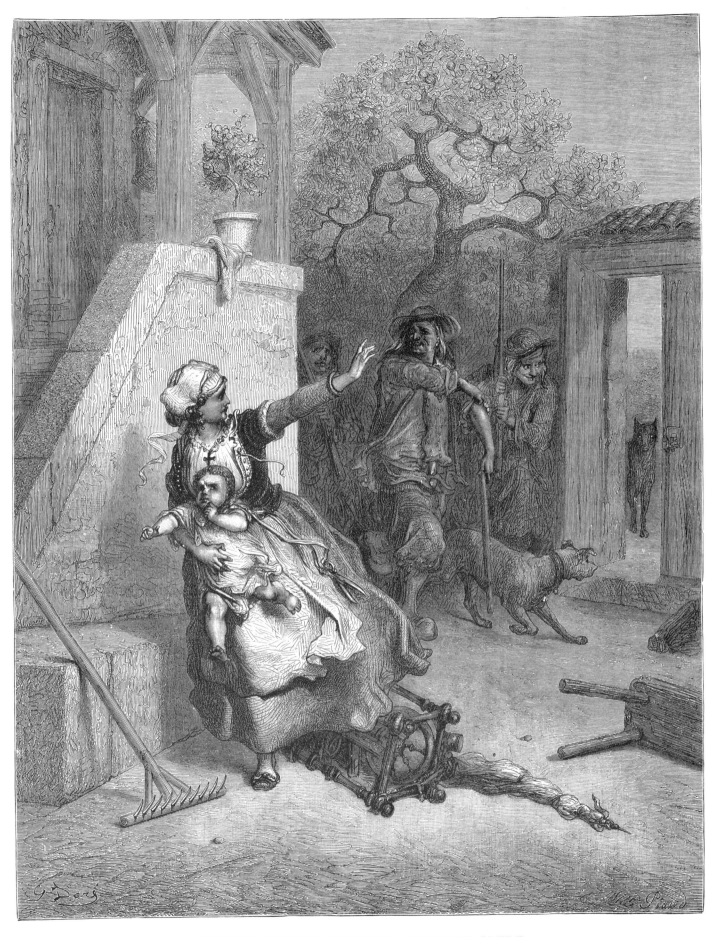

THE WOLF, THE MOTHER, AND THE CHILD
[Le Loup, la Mère, et l'Enfant]

Never thinking it would come to pass, the angry mother
threatened to give her crying child to the wolves.

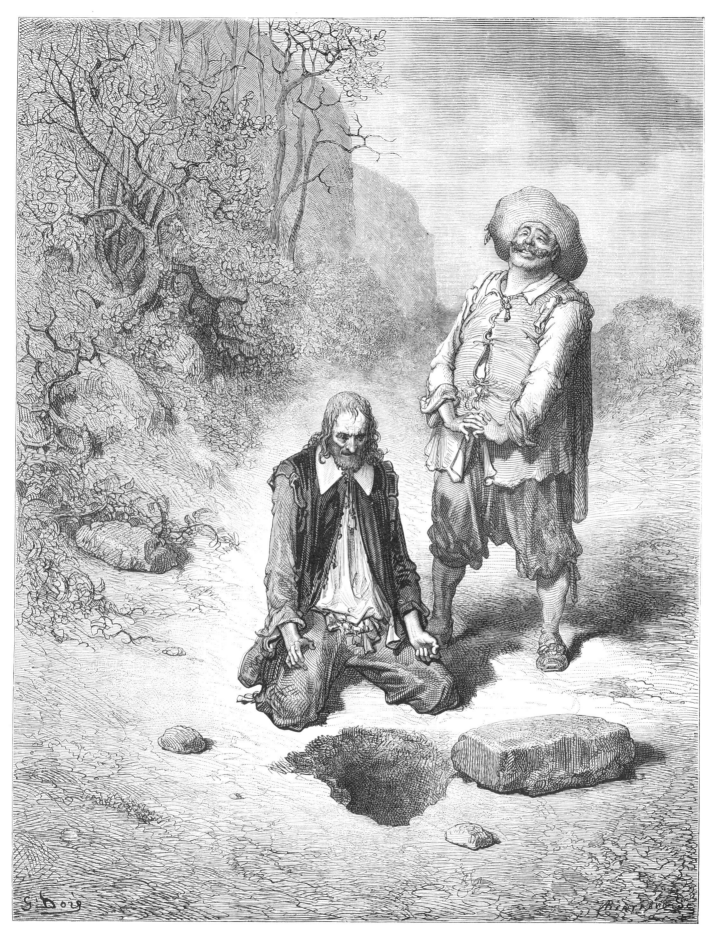

THE MISER WHO LOST HIS TREASURE
[L'Avare Qui a Perdu son Trésor]

The miser despaired of his loss when he found his gold taken, but he had never used it in any case.

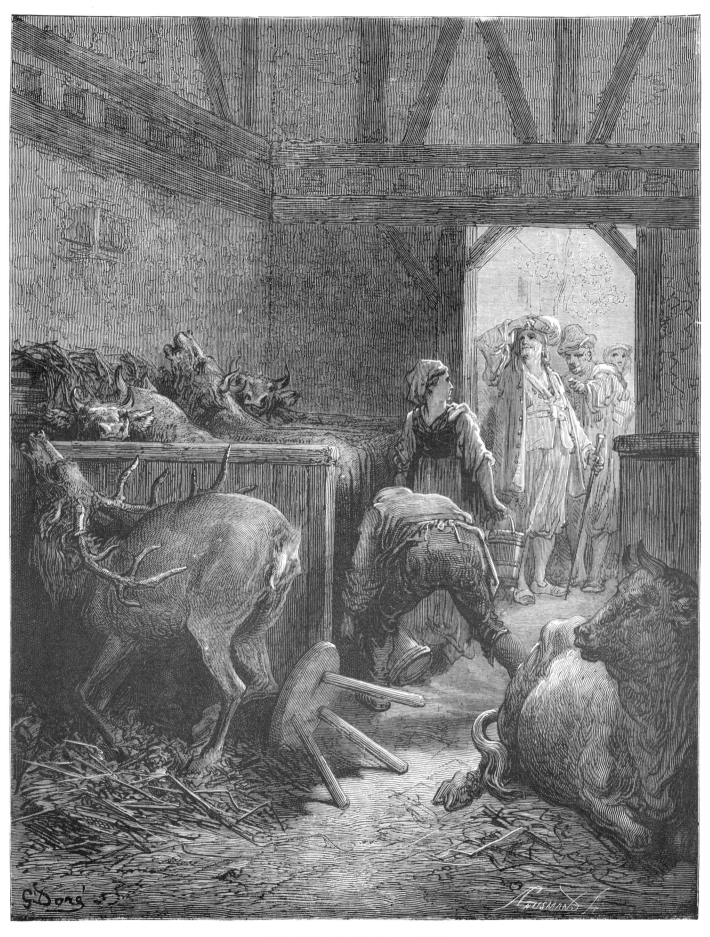

THE EYE OF THE MASTER
[L'Oeil du Maître]

The stag thought that he was hidden safely and his life saved,
but he could not escape the keen eye of the master.

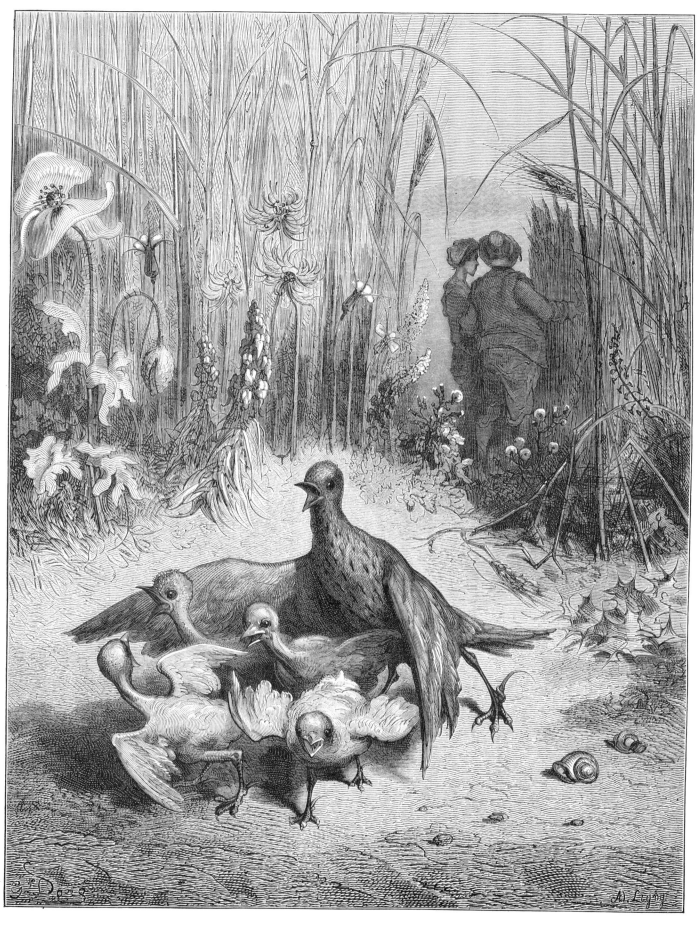

THE LARK AND HER BABIES AND THE LANDOWNER
[L'Allouette et ses Petits avec le Maître d'un Champ]

When the owner and his son realized that it was time to reap,
the lark knew it was time to fly away.

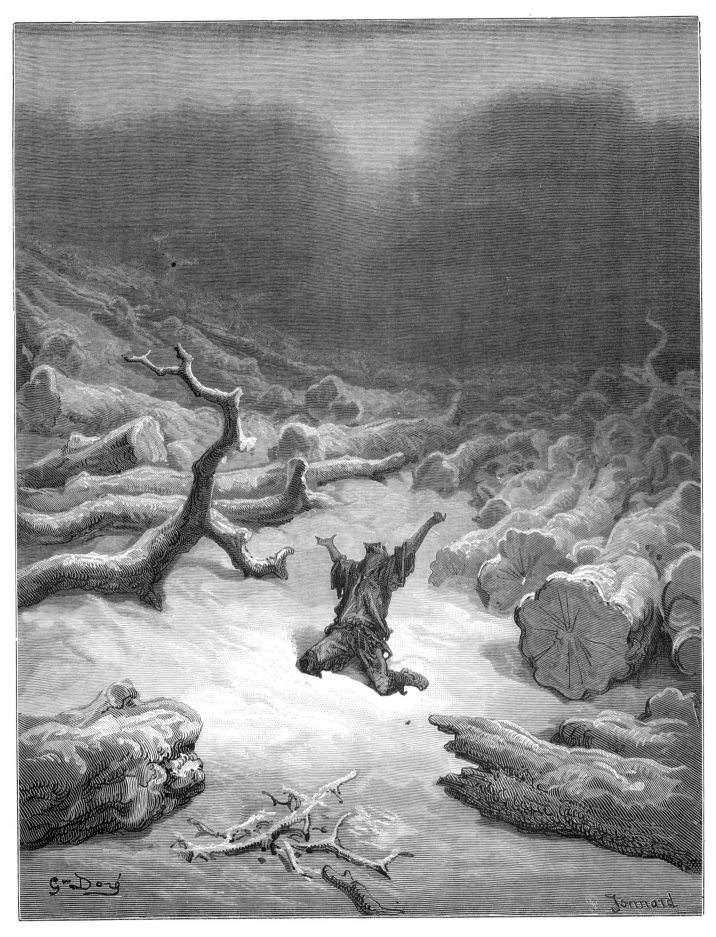

THE WOODMAN AND MERCURY
[Le Boucheron et Mercure]

The desperate woodman begged Jupiter to return his axe to him so he could earn his living.

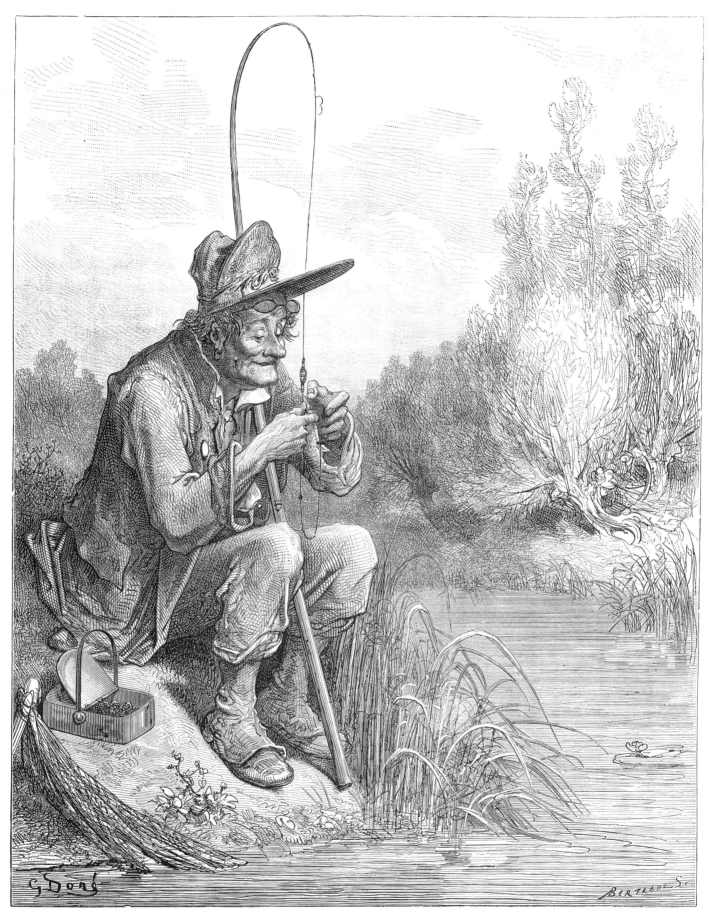

THE LITTLE FISH AND THE FISHERMAN
[Le Petit Poisson et le Pêcheur]

The fisherman was content to fry a young fish, rather than take a chance
in hooking it when it had grown.

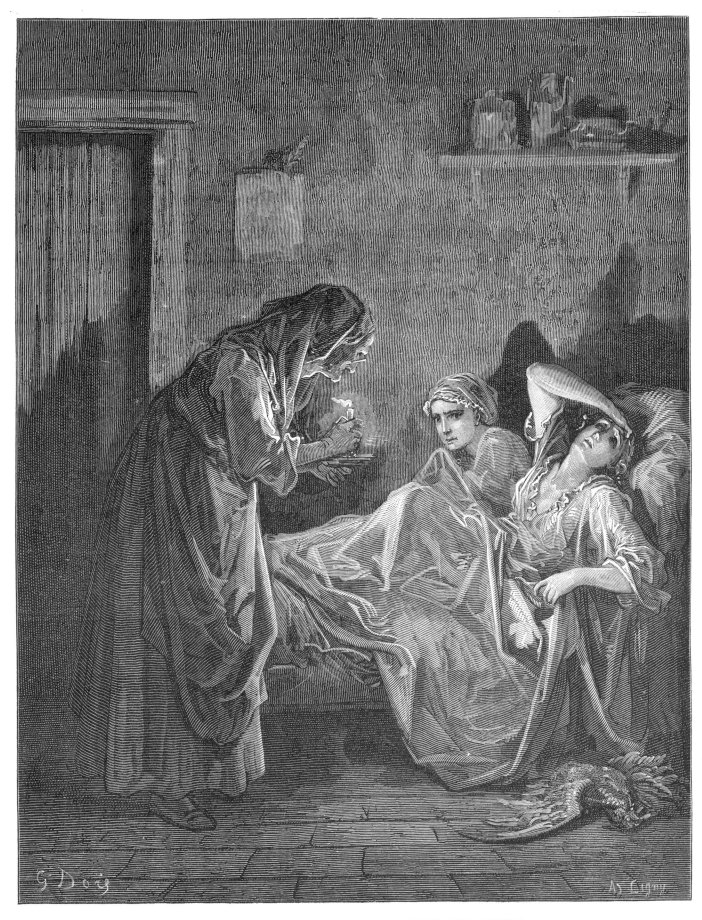

THE OLD WOMAN AND THE SERVANT-GIRLS
[La Vieille et les Deux Servantes]

Having killed the rooster, the servant-girls were now awakened by their insistent mistress.

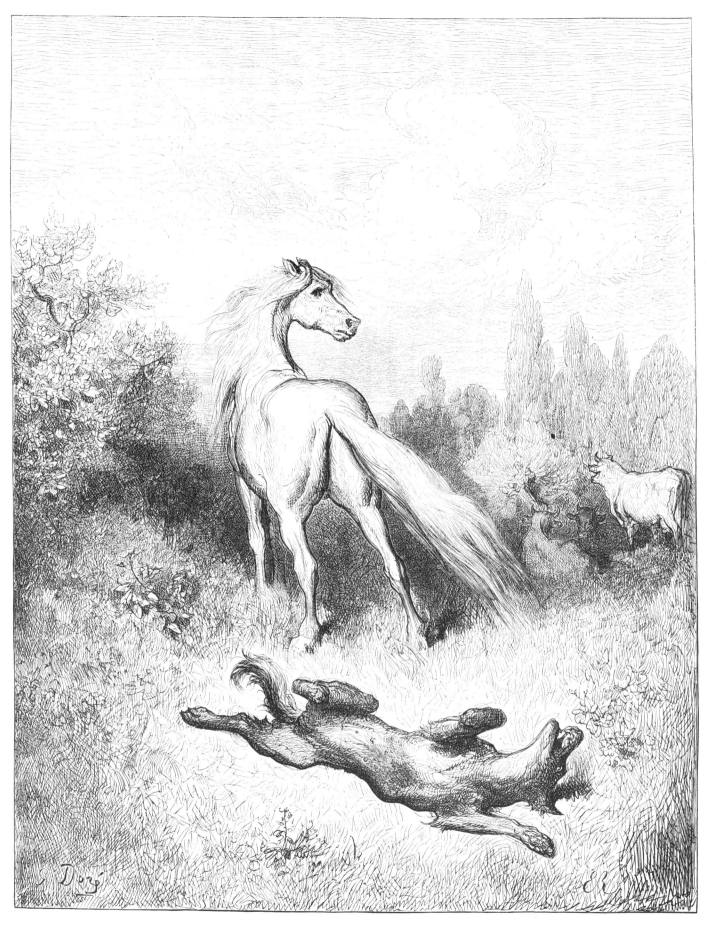

THE HORSE AND THE WOLF
[Le Cheval et le Loup]

Pretending to be a healer, the wolf invited the horse's suspicion and was overcome.

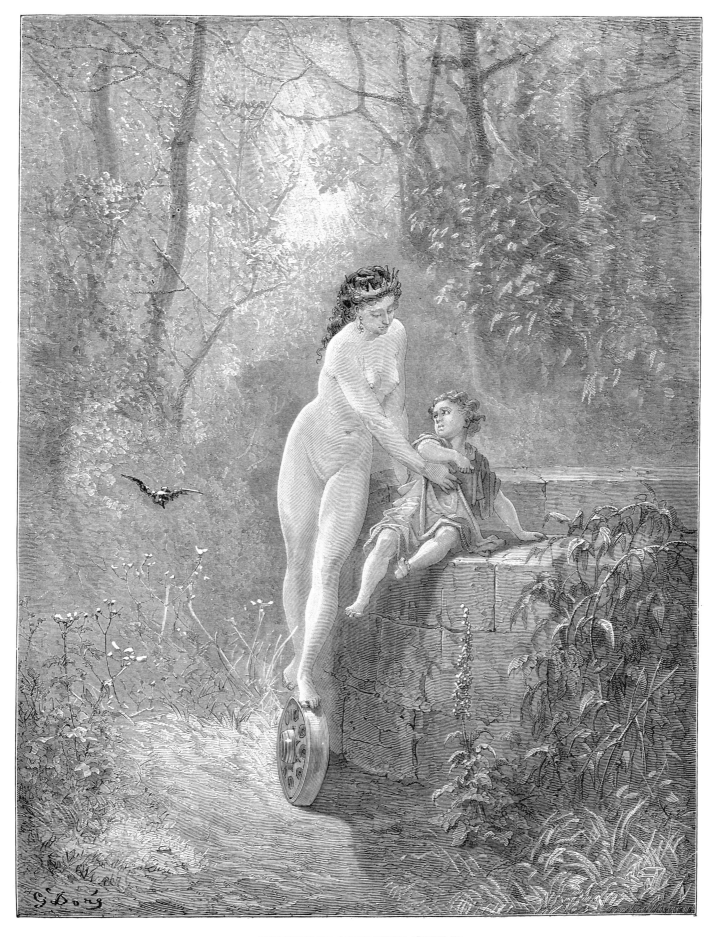

FORTUNE AND THE CHILD
[La Fortune et le Jeune Enfant]

Fortune warned the child of his danger, knowing that she would be blamed if he were hurt.

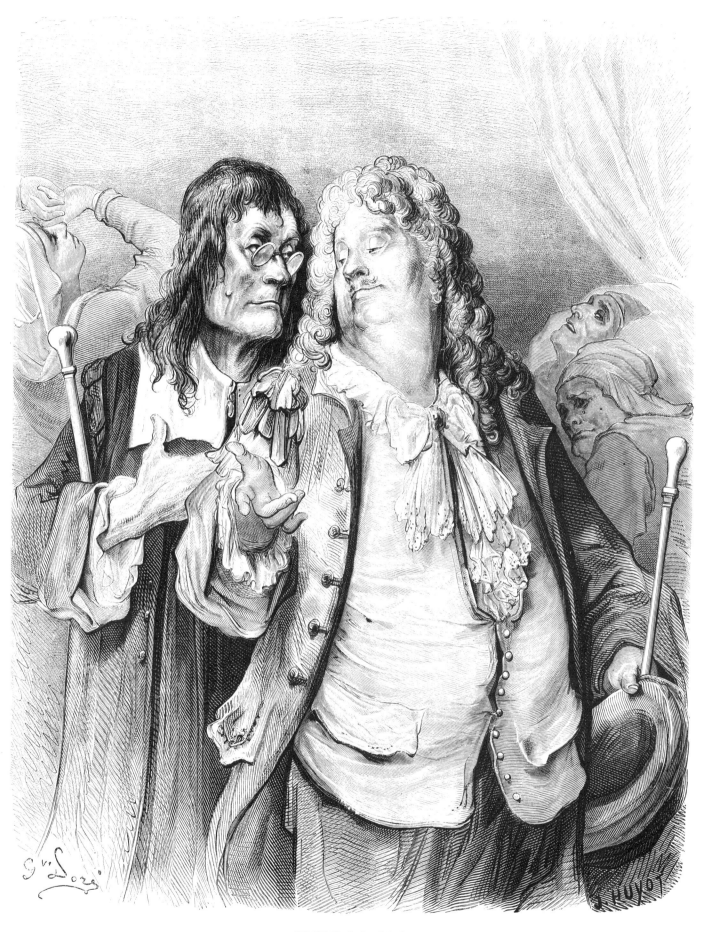

THE DOCTORS
[Les Médecins]

While the doctors argued about his treatment, the patient died.

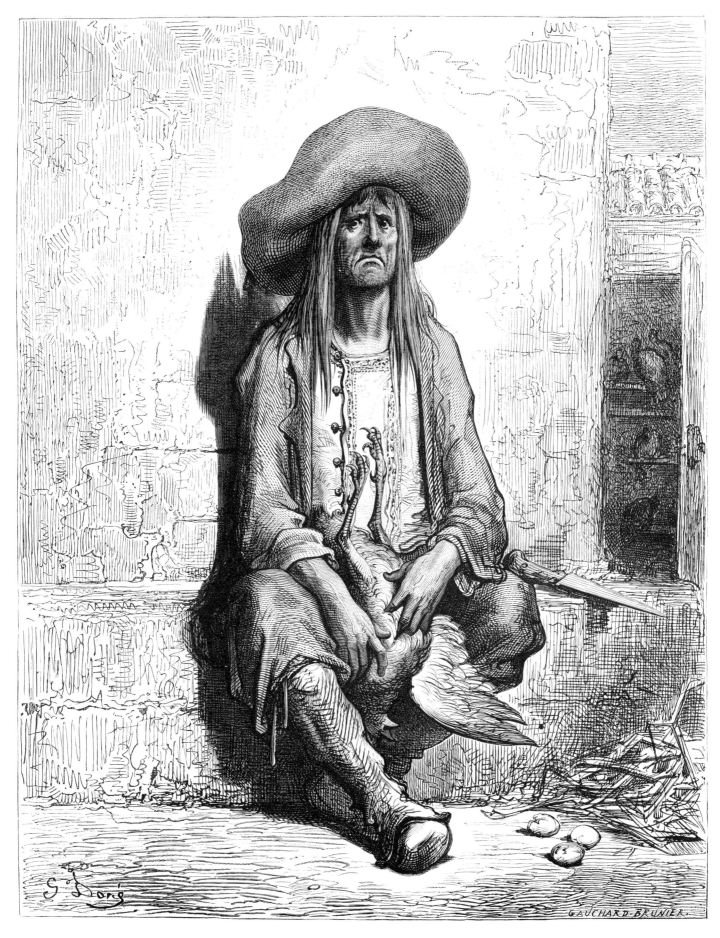

THE HEN WITH GOLDEN EGGS
[La Poule aux Oeufs d'Or]

His greed and stupidity led him to kill the source of his wealth.

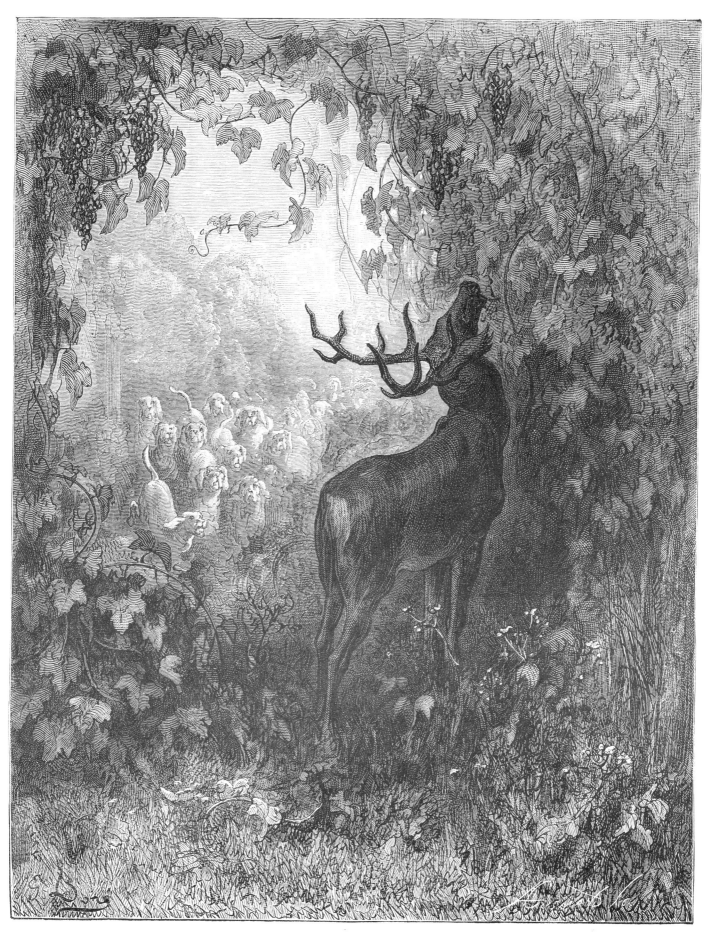

THE STAG AND THE VINE
[Le Cerf et la Vigne]

Eating the vines that had hidden him, the stag was set upon by the hunters.

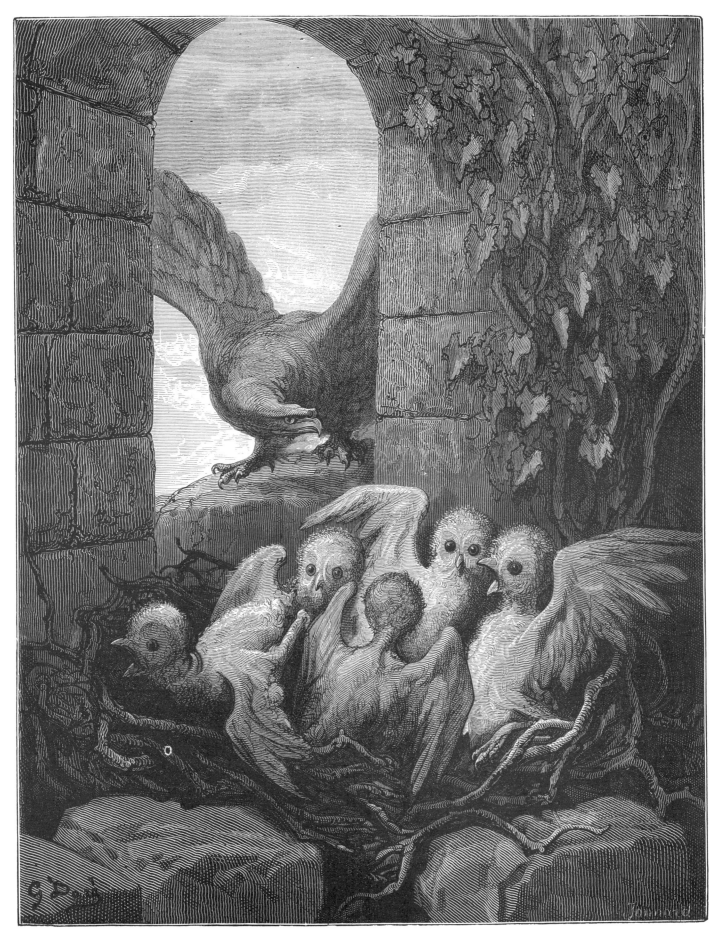

THE EAGLE AND THE OWL
[L'Aigle et le Hibou]

The Eagle was confused by the owl's description of her chicks and unwittingly consumed them all.

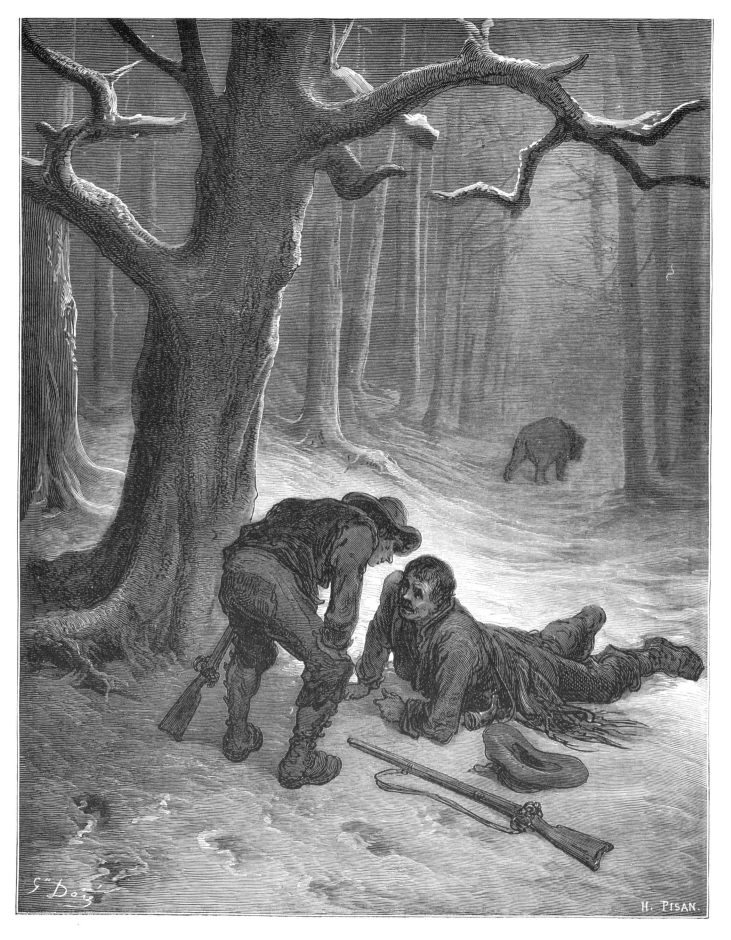

THE BEAR AND THE TWO FRIENDS
[L'Ours et les Deux Compagnons]

One friend saved his life by outsmarting the bear, but he lost the pelt,
for which he had already been paid.

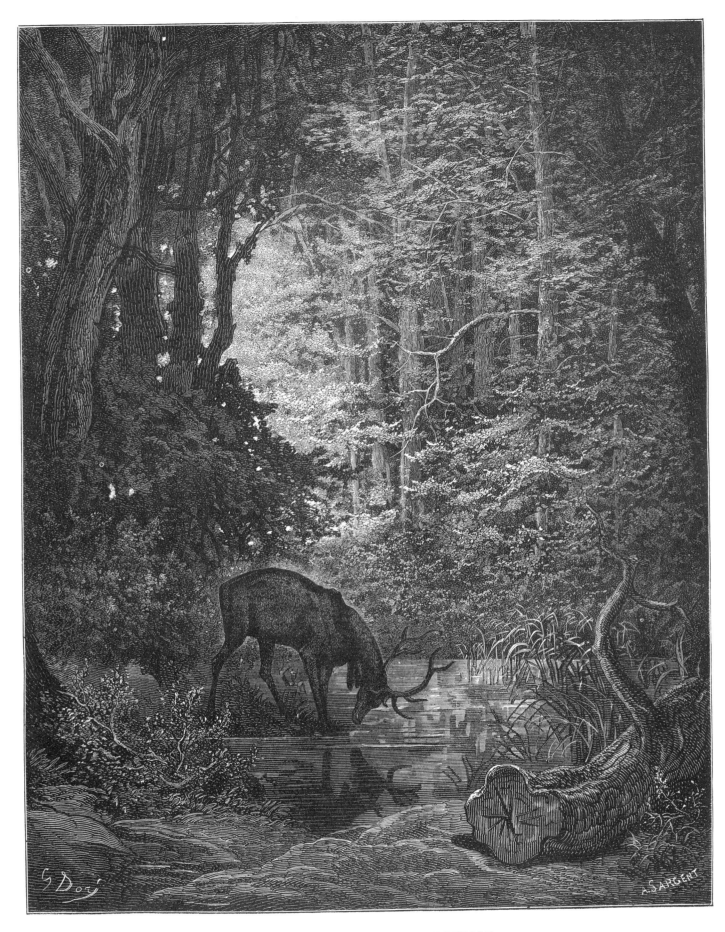

THE STAG SEES HIS REFLECTION
[Le Cerf Se Voyant dans l'Eau]

The stag rued his slender legs, but was grateful for them as he fled his pursuer.

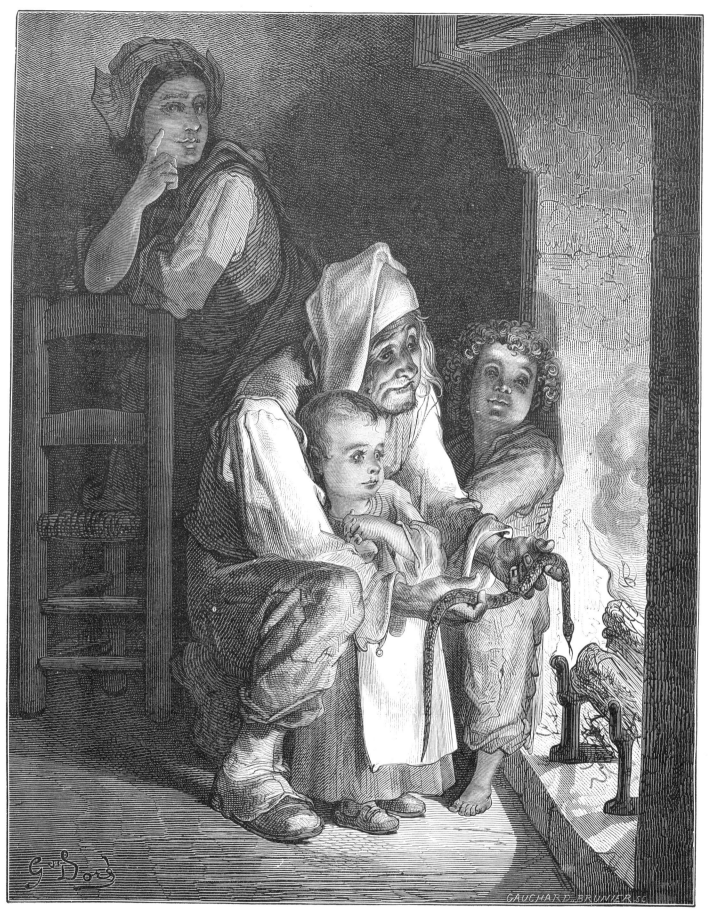

THE PEASANT AND THE SNAKE
[Le Villageois et le Serpent]

The kindly peasant took a risk when he brought home the dying snake and revived it.

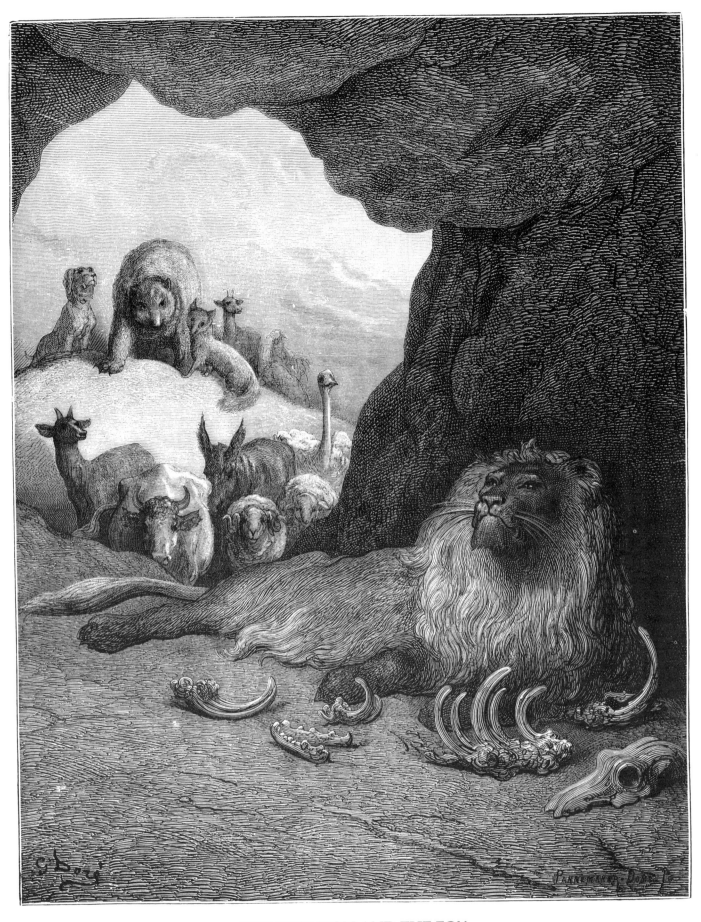

THE SICK LION AND THE FOX
[Le Lion Malade et le Renard]

Even with assurances of safety from the ailing king of beasts, the fox still hesitated to pay a visit.

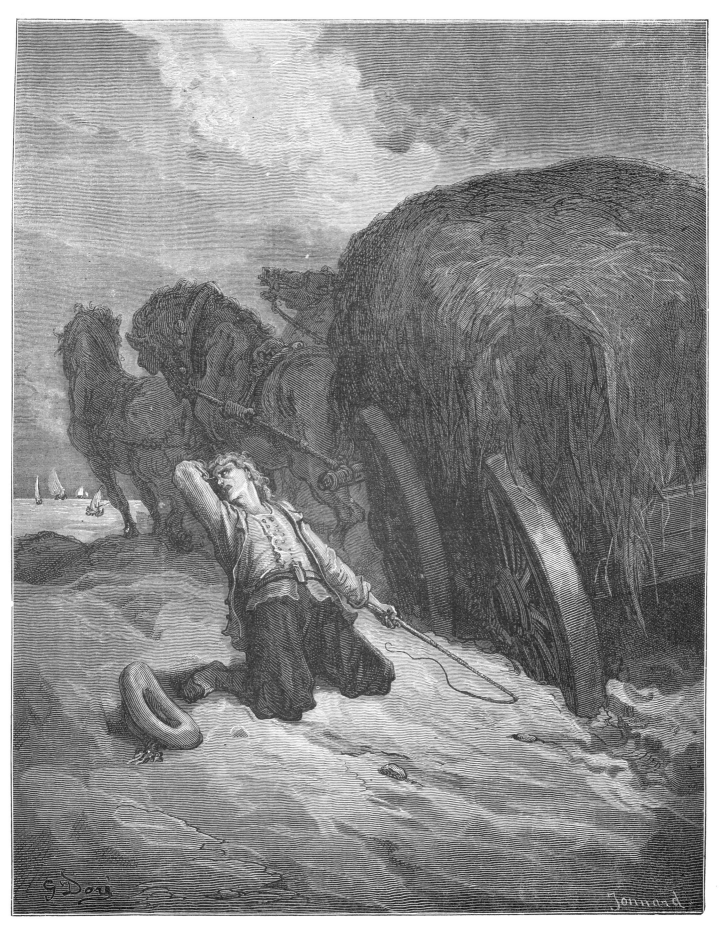

THE CARTER STUCK IN THE MUD
[Le Chartier Embourbé]

The carter beseeched Hercules for help in freeing his cart
and was instructed how to do the work himself.

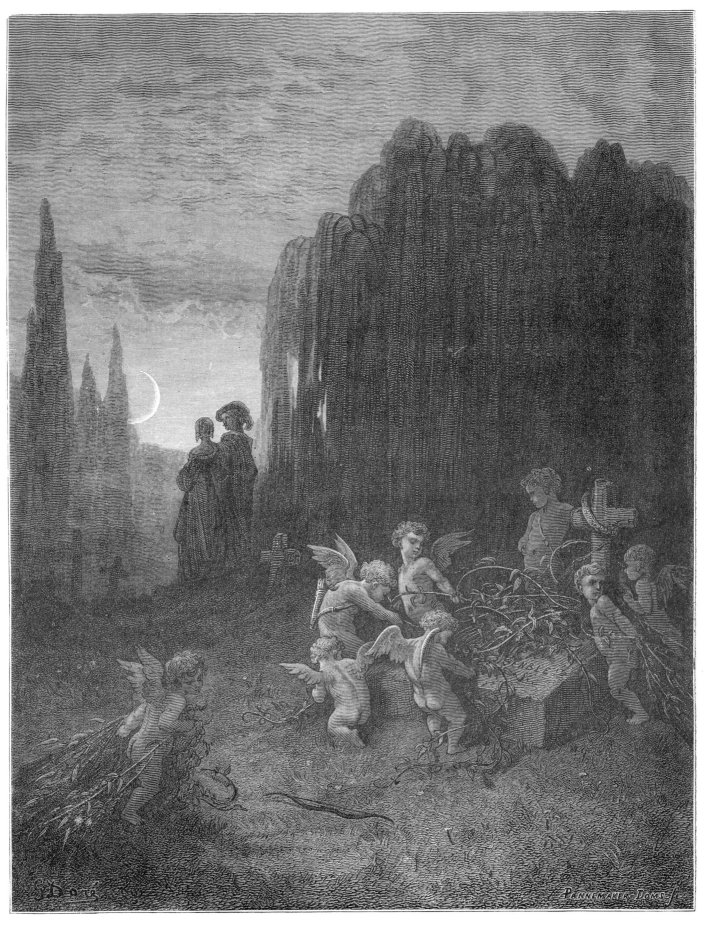

THE YOUNG WIDOW
[La Jeune Veuve]

The worldly father advised his grieving daughter to end her mourning and forget her beloved.

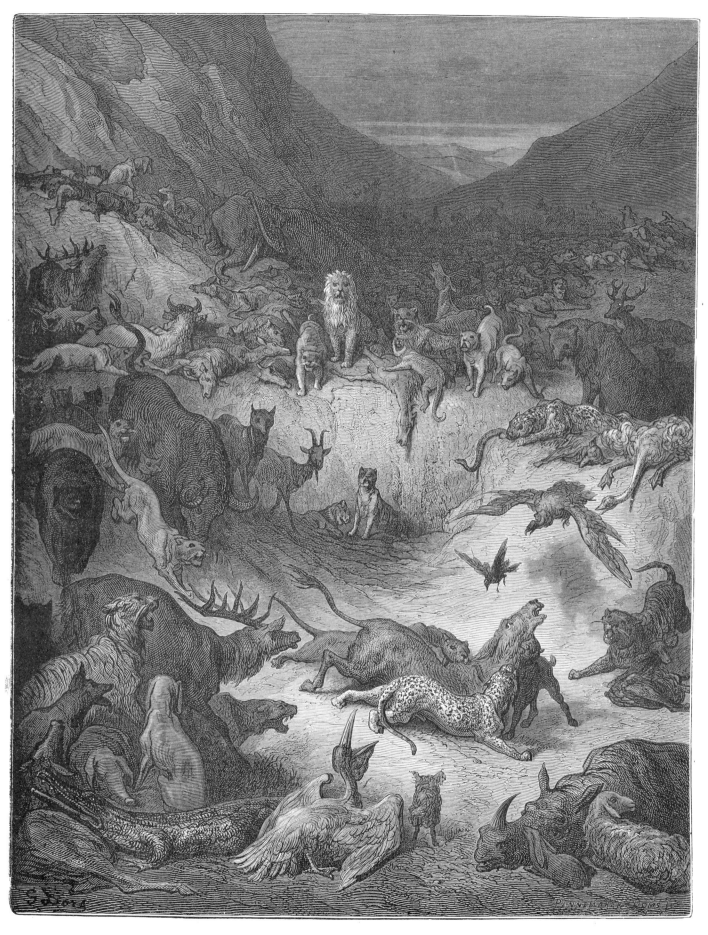

THE ANIMALS SICKENED BY THE PLAGUE
[Les Animaux Malades de la Peste]

While the other animals cleverly avoided death, the ass's truthful
confession led to his being sacrificed.

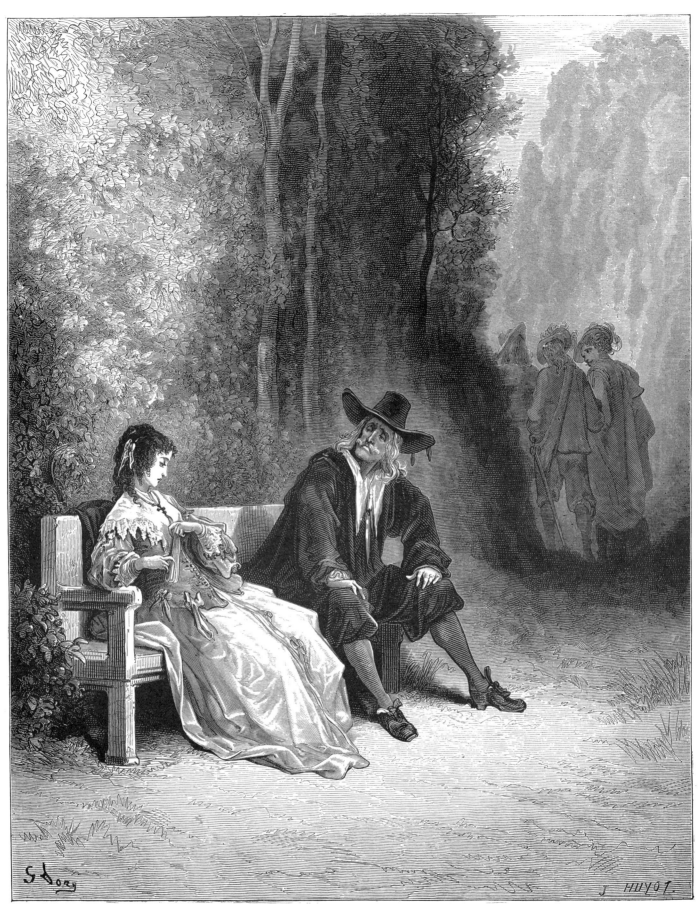

THE MAIDEN
[La Fille]

Discriminating to a fault, the maiden finally married an inferior suitor.

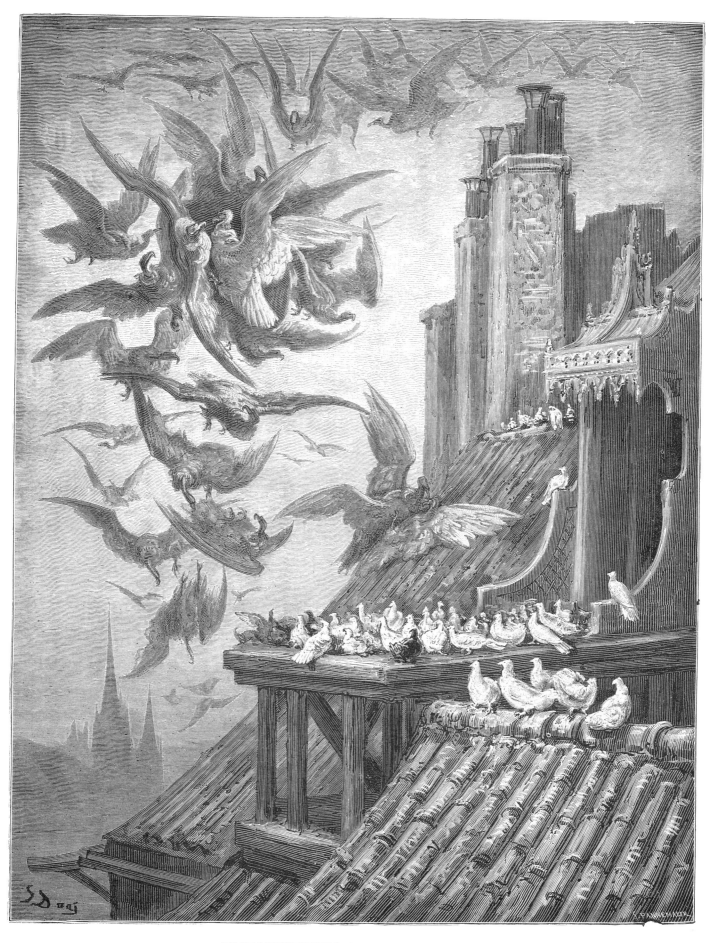

THE VULTURES AND THE PIGEONS
[Les Vautours et les Pigeons]

The pigeons had good intentions but were unable to escape the vultures' bloodthirsty nature.

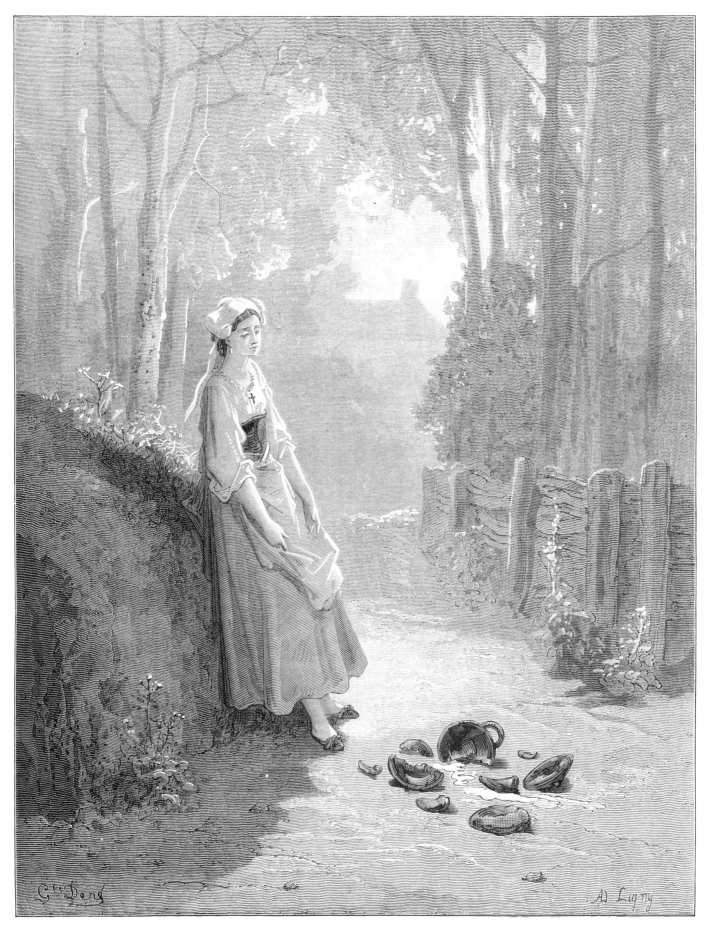

THE MILKMAID AND THE PITCHER
[La Laitière et le Pot au Lait]

Caught up in her dreams of future gain, the milkmaid skipped gaily, spilling her "fortune."

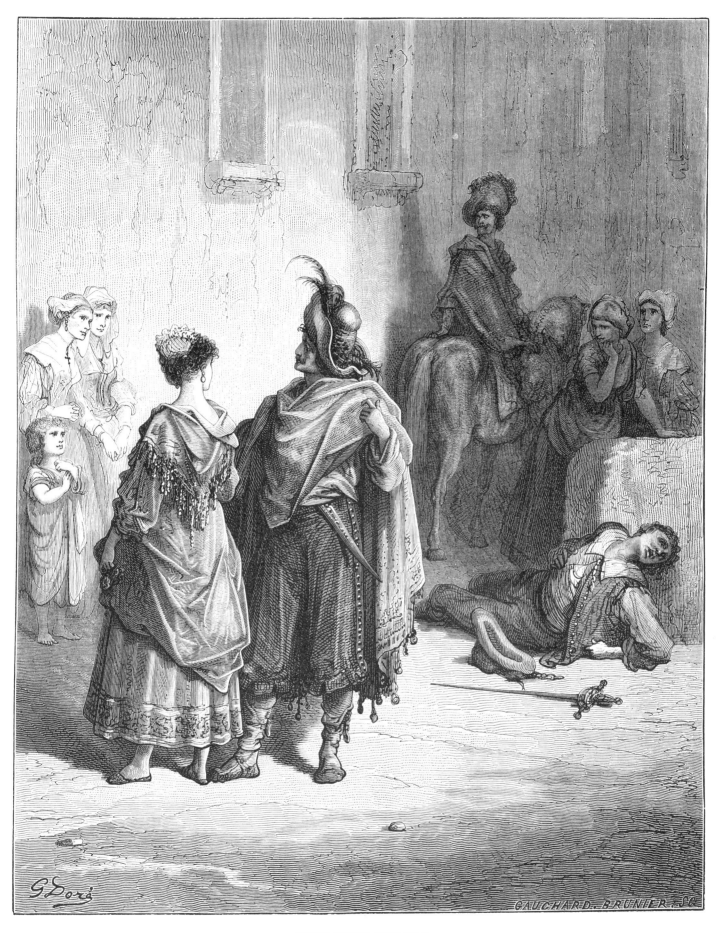

THE TWO FOWLS
[Les Deux Coqs]

The conqueror, in boasting of his victory, drew the notice of Fortune and was struck down.

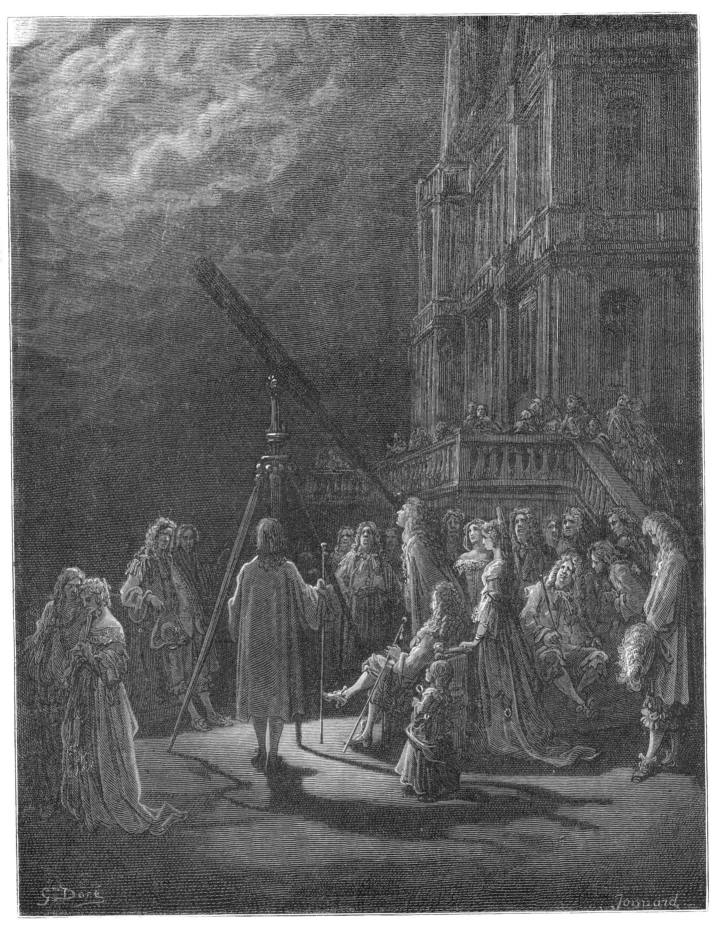

AN ANIMAL IN THE MOON
[Un Animal dans la Lune]

Trusting to their senses, rather than reason, they mistook
a tiny mouse between the lenses as a monster.

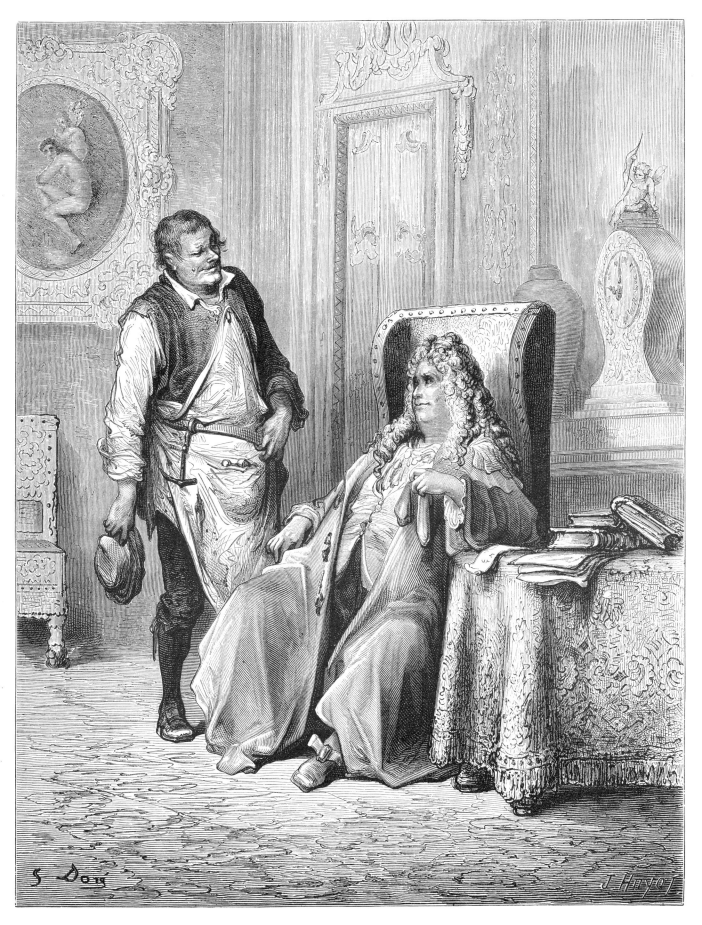

THE COBBLER AND THE BANKER
[Le Savetier et le Financier]

Rather than enjoy his new wealth, the once-merry cobbler was now consumed by fear of loss.

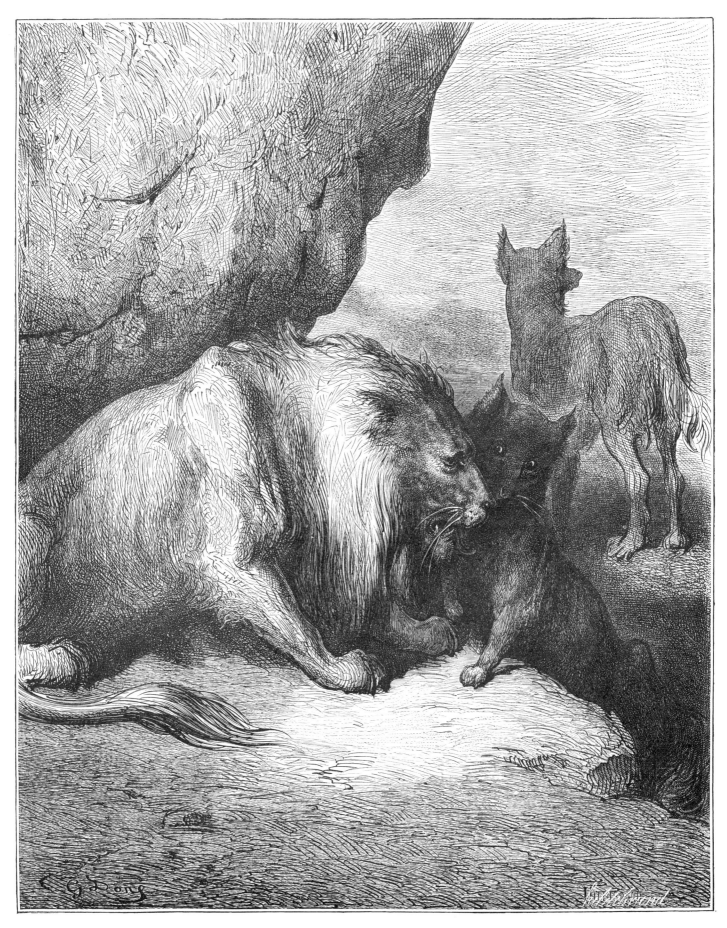

THE LION, THE WOLF, AND THE FOX
[Le Lion, le Loup, et le Renard]

The fox took his revenge on the wolf, who had tried to gain favor with the lion by betraying the fox.

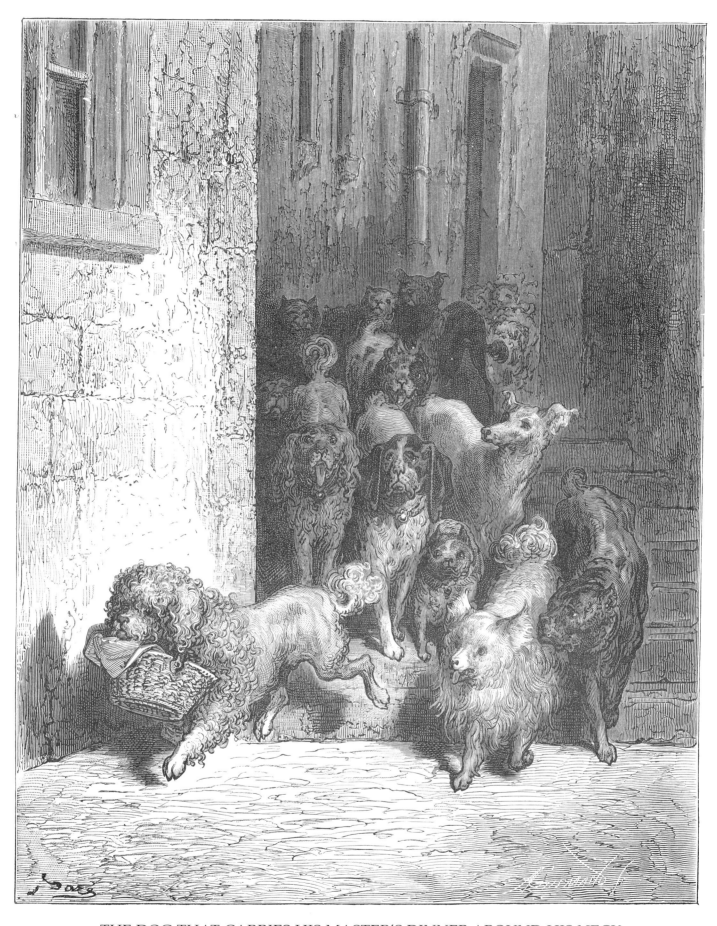

THE DOG THAT CARRIES HIS MASTER'S DINNER AROUND HIS NECK
[Le Chien qui Porte à son Cou le Dîné de son Maître]

When his master's meal was threatened, the dog was the first to take a choice part.

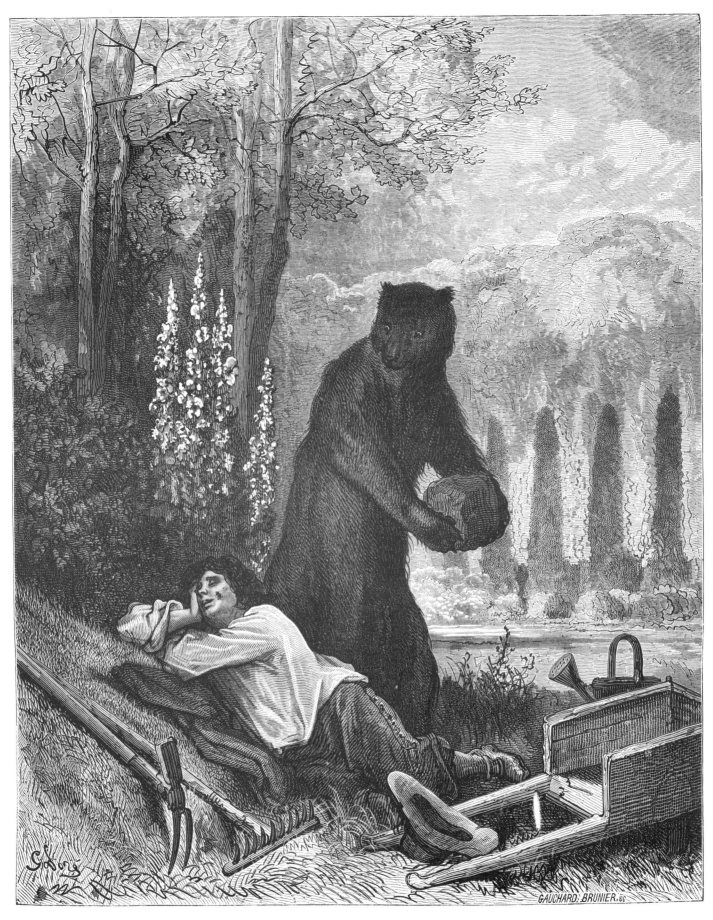

THE BEAR AND THE AMATEUR GARDENER

[L'Ours et l'Amateur des Jardins]

The gardener would have been better off lonely than a friend of the thoughtless beast.

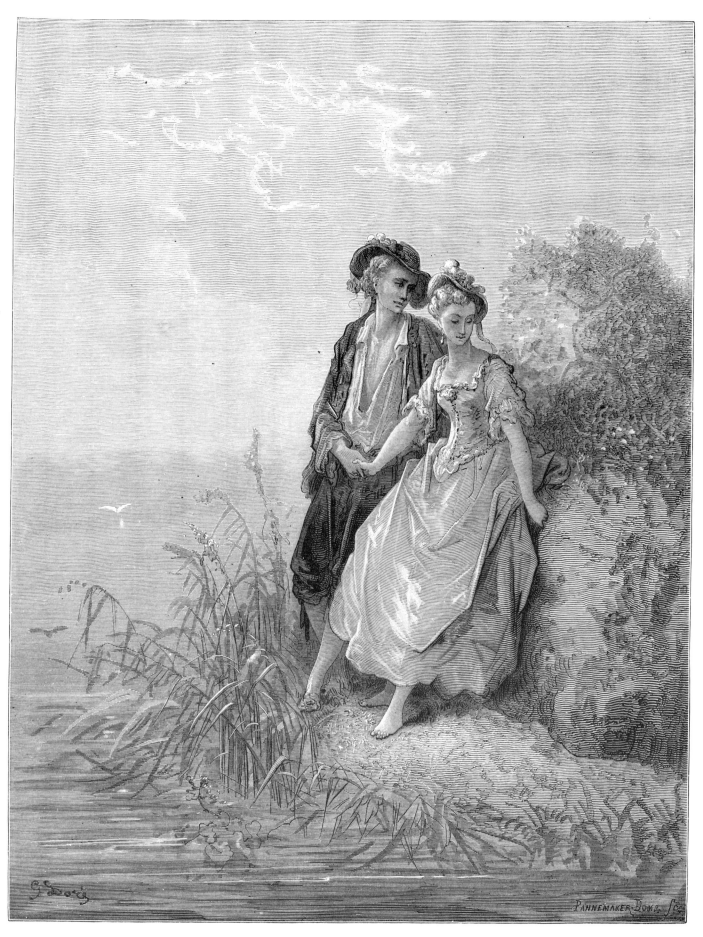

TIRCIS AND AMARANTE
[Tircis et Amarante]

Tircis, in identifying the source of Amarante's pain, discovered that her pining was for another.

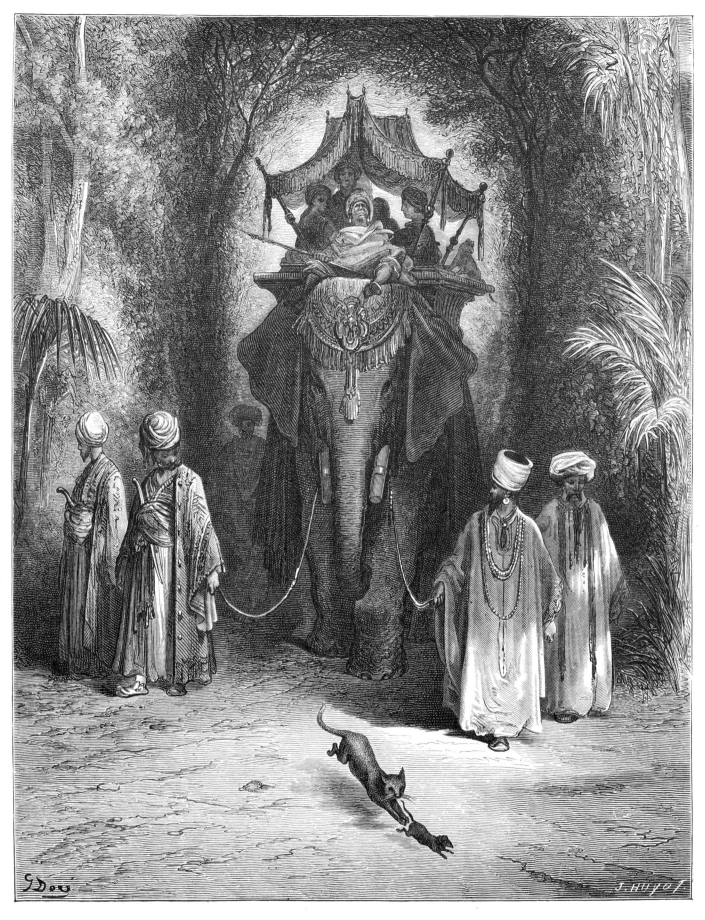

THE RAT AND THE ELEPHANT
[Le Rat et l'Éléphant]

The rat, thinking itself important, was soon to find that it was not mighty at all.

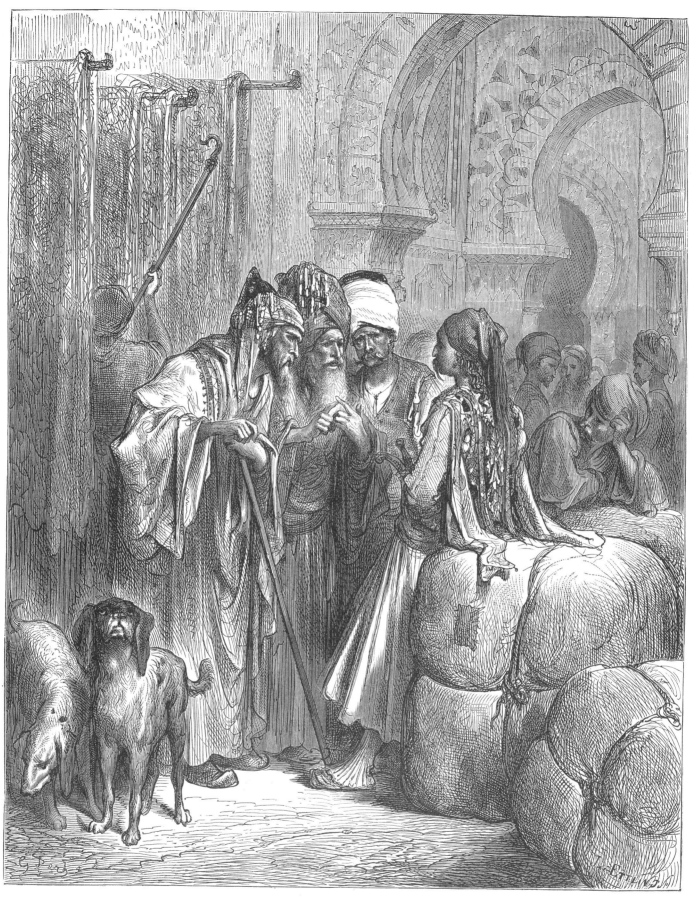

THE PASHA AND THE MERCHANT
[Le Bassa et le Marchand]

The merchant was persuaded to buy protection cheap, foolishly leaving himself vulnerable.

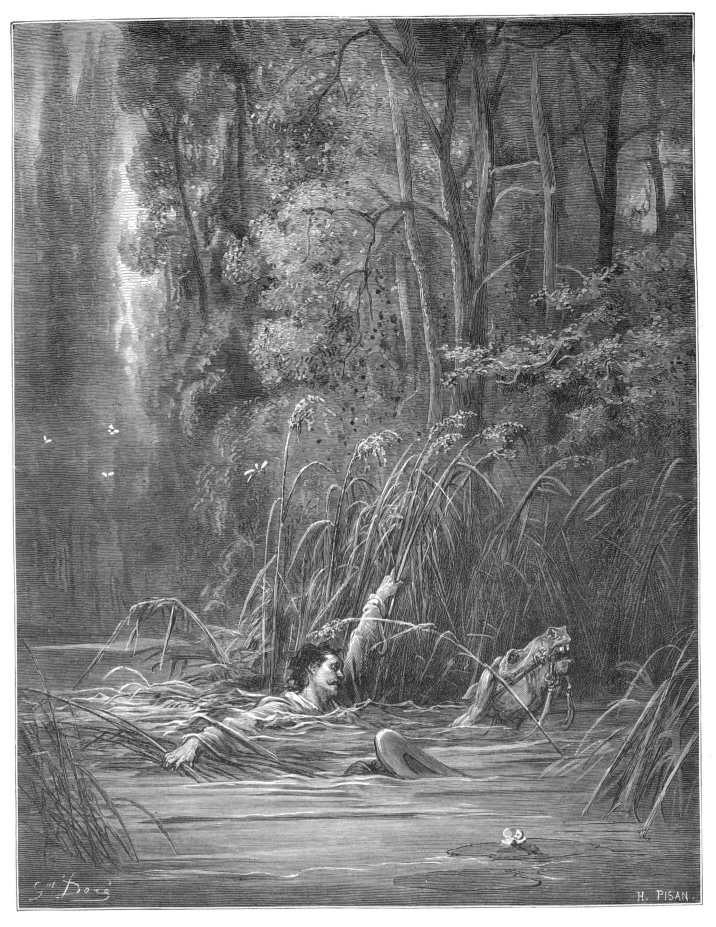

THE TORRENT AND THE RIVER
[Le Torrent et la Rivière]

Thinking he had cheated death in still waters, he misjudged the depth and drowned.

54

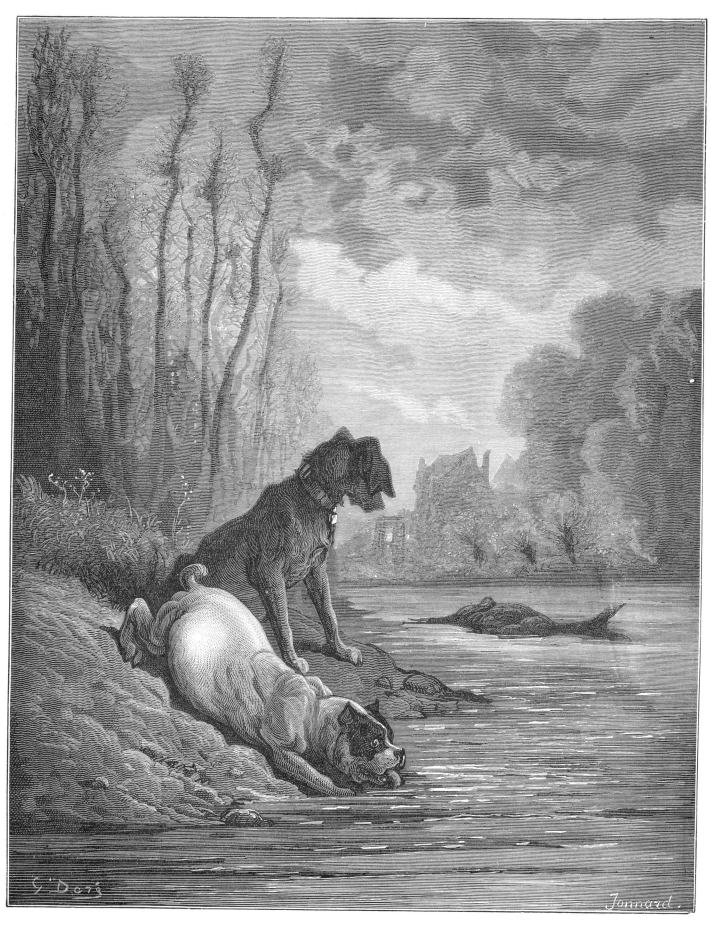

THE TWO DOGS AND THE DEAD ASS
[Les Deux Chiens et l'Ane Mort]

The hungry dogs can never reach the object of their desire, even though they try to drink the river dry.

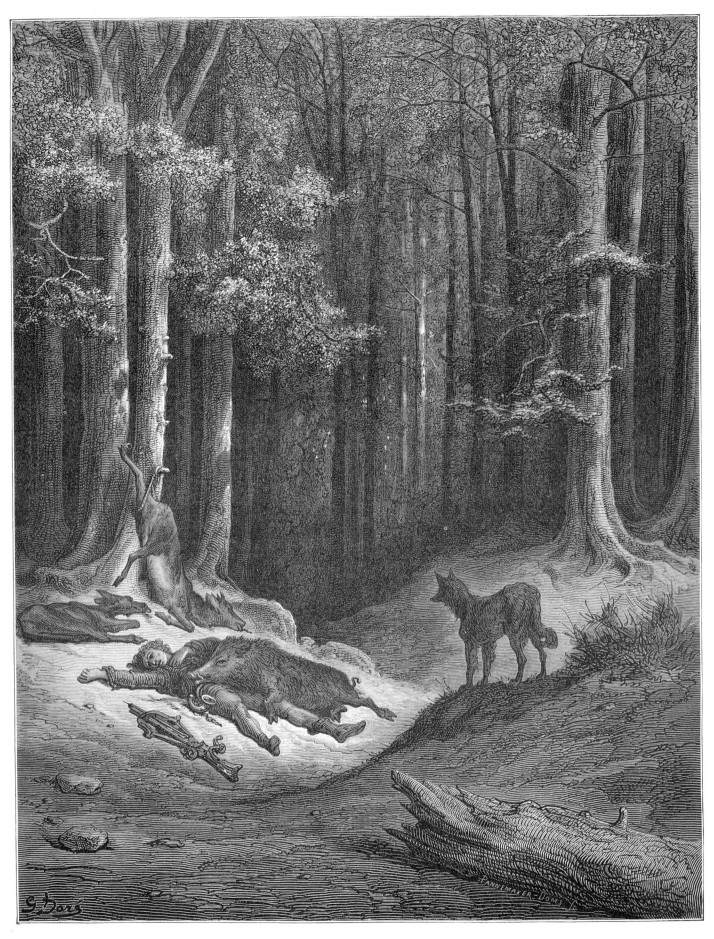

THE WOLF AND THE HUNTER
[Le Loup et le Chasseur]

The hunter, not content with his catch, was slain by his greed for yet another prize.

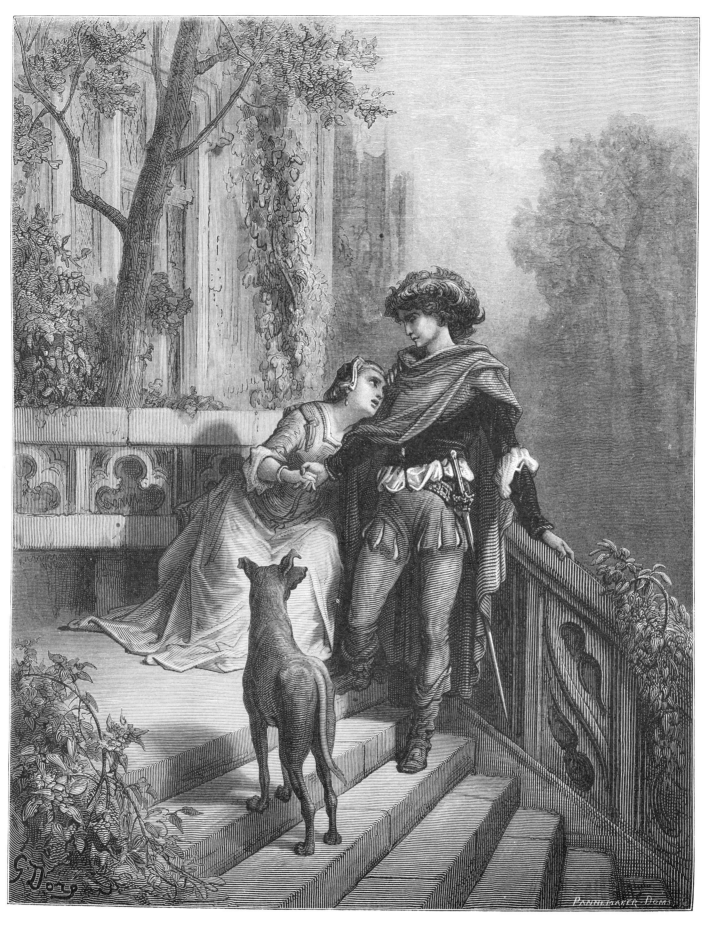

THE TWO PIGEONS
[Les Deux Pigeons]

Do not wander from your true love, or you may never find the way to love's path again.

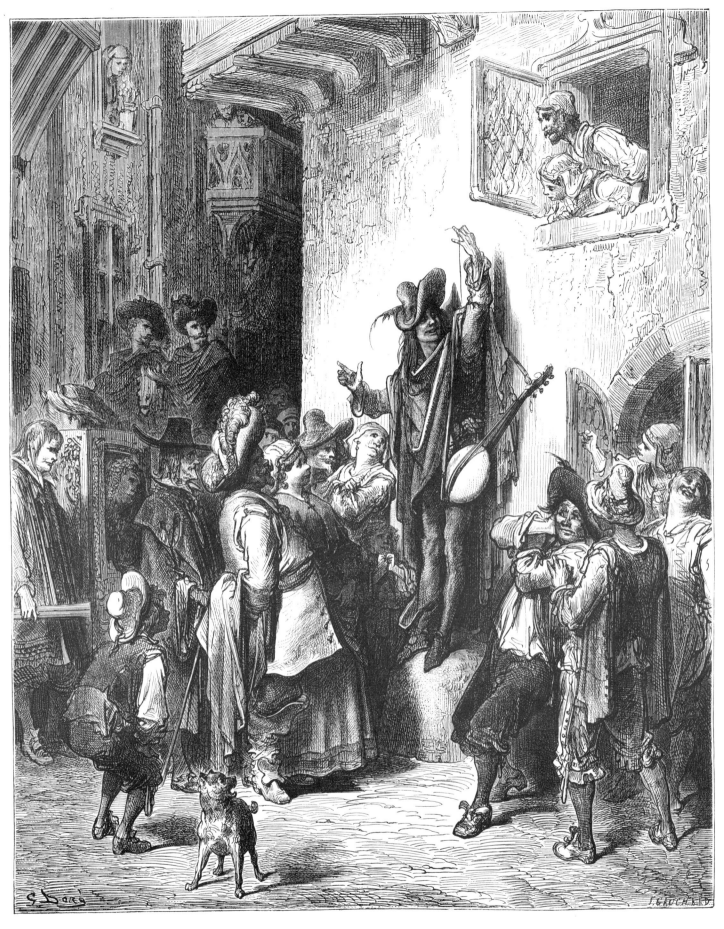

THE MADMAN WHO SOLD WISDOM
[Le Fou Qui Vend la Sagesse]

Many gullible folk are taken in by "wisdom" persuasively sold.

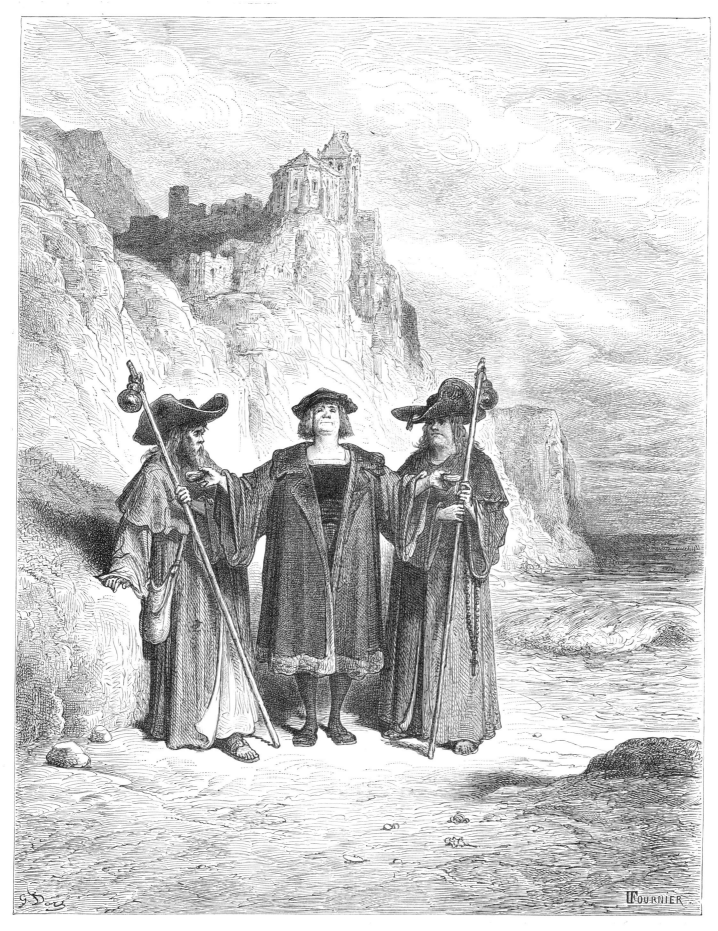

THE OYSTER AND ITS CLAIMANTS
[L'Huître et les Plaideurs]

The lawyer settled the dispute, but his clients were the losers.

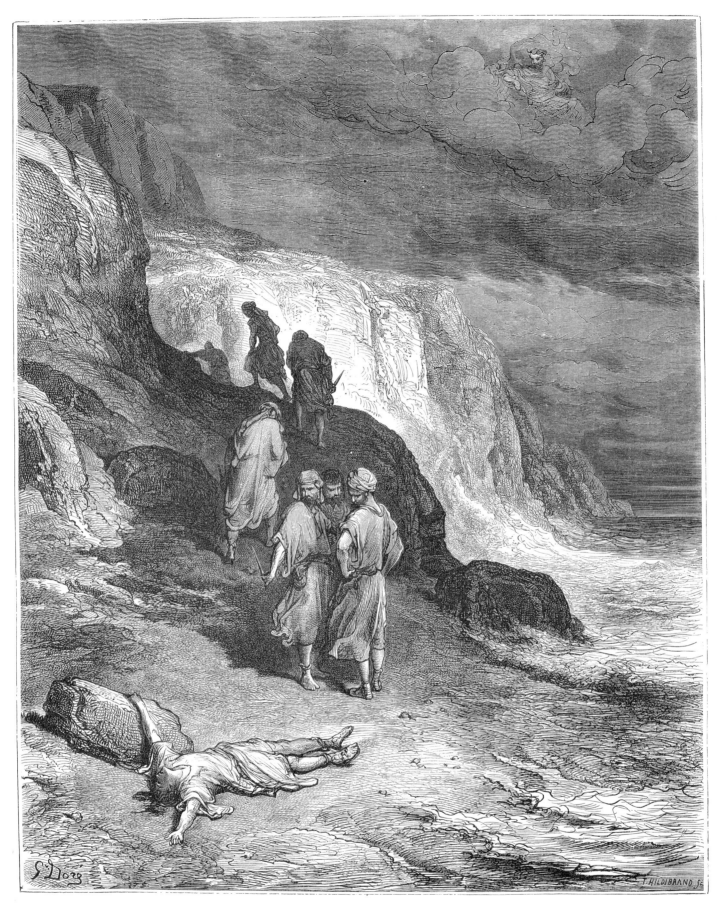

JUPITER AND THE TRAVELER
[Jupiter et le Passager]

The traveler's empty promises were his undoing.

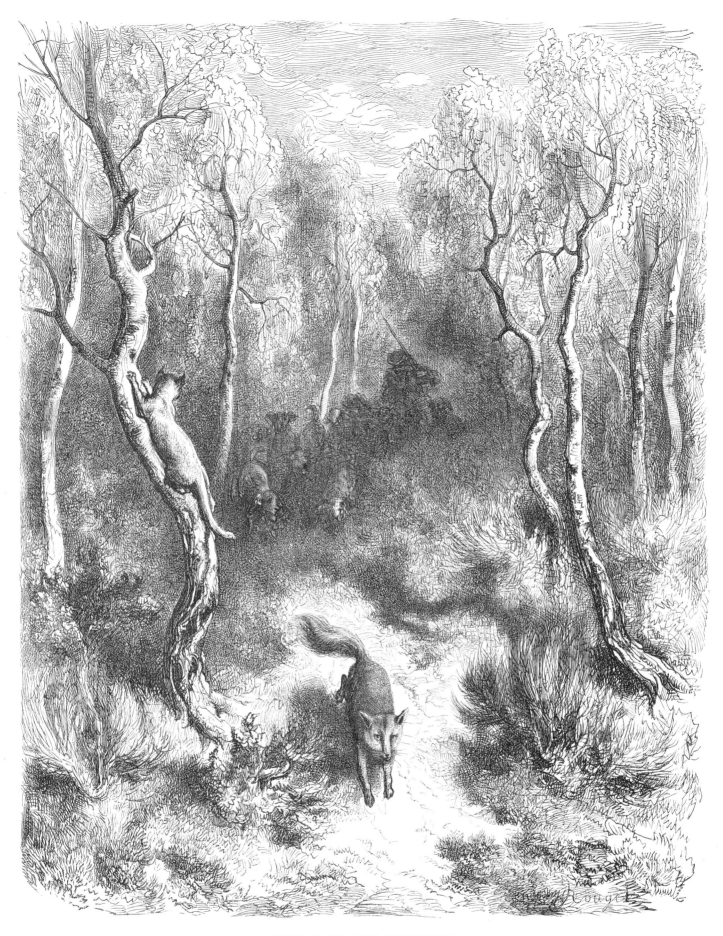

THE CAT AND THE FOX
[Le Chat et le Renard]

The cat ran up a tree, while the fox, weighing his many escape plans, fell prey to the hounds.

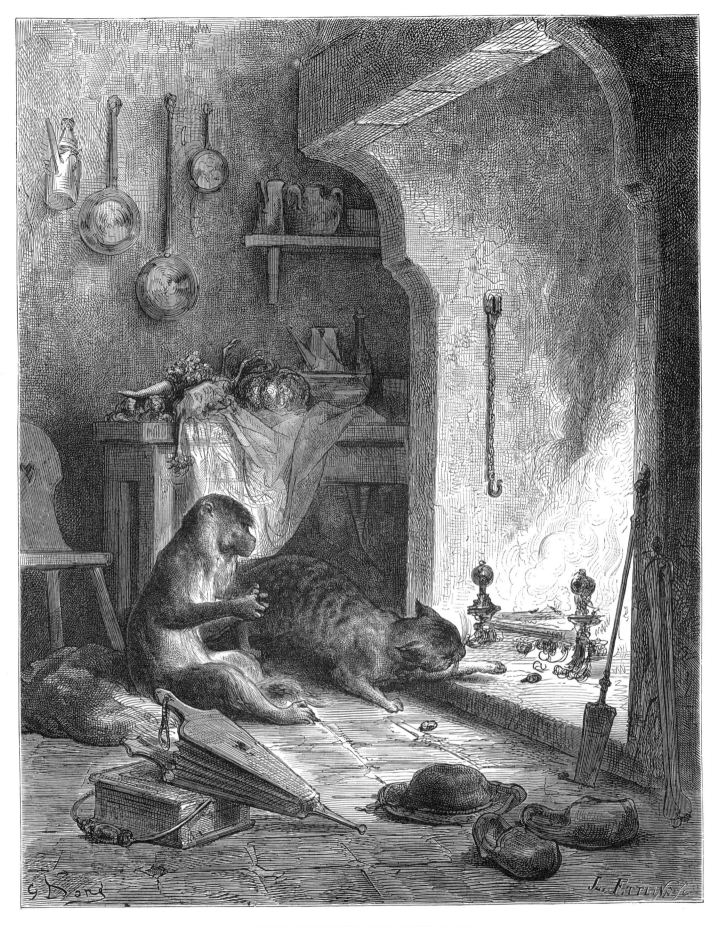

THE MONKEY AND THE CAT
[Le Singe et le Chat]

The cat did the dangerous deed to please his friend but was empty-handed for all his pains.

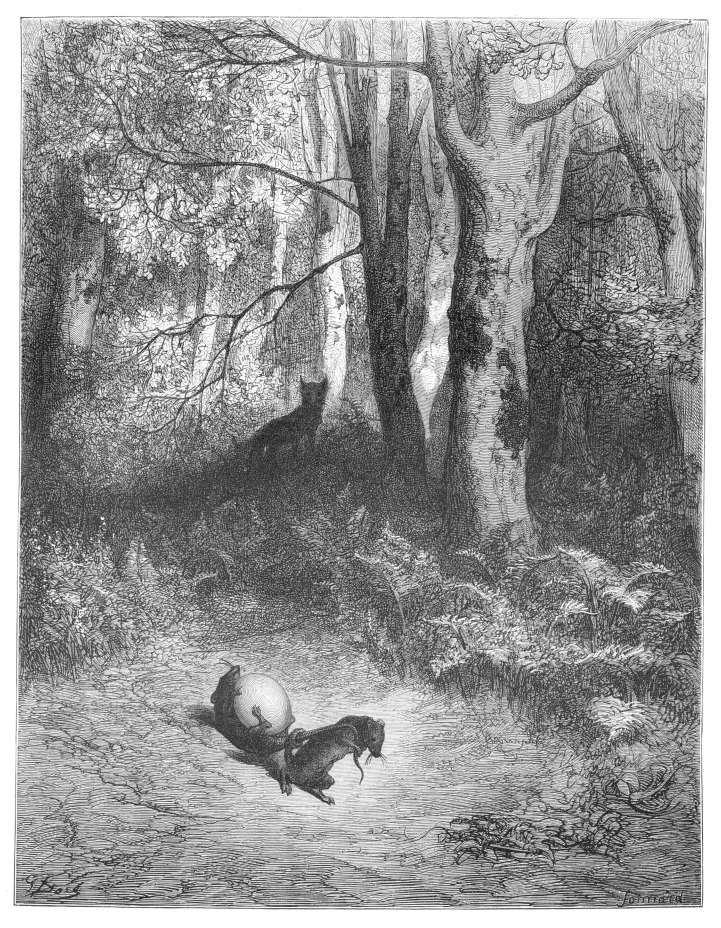

TWO RATS, THE FOX, AND THE EGG
[Les Deux Rats, le Renard et l'Oeuf]

Although they lack a soul, animals still possess craft and invention.

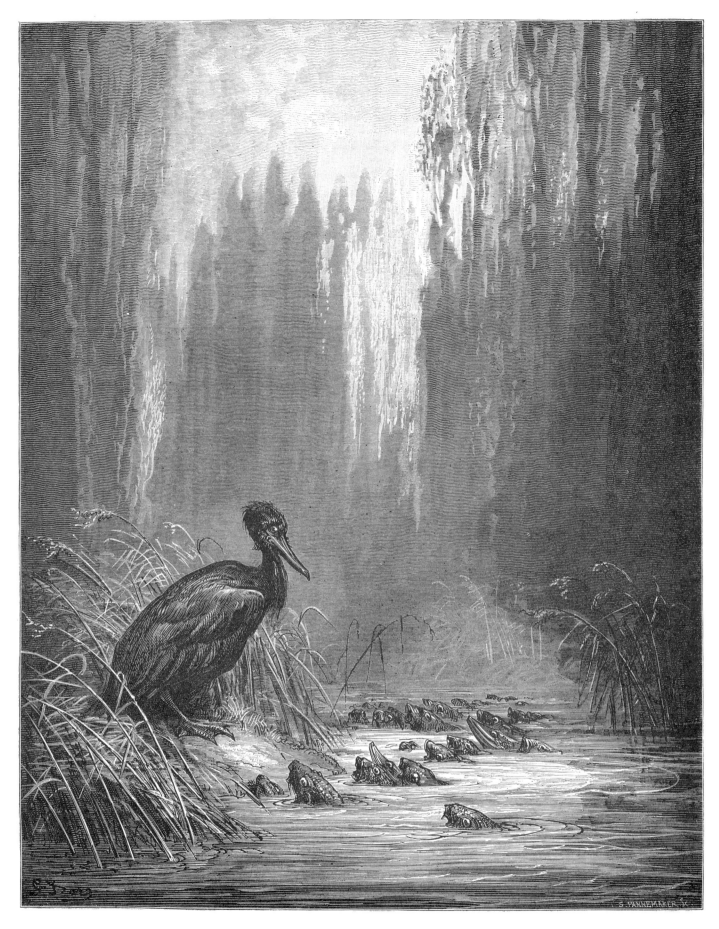

THE FISH AND THE CORMORANT
[Les Poissons et le Cormoran]

One cannot avoid one's fate: The fish are on the cormorant's
plate today, rather than the fisherman's tomorrow.

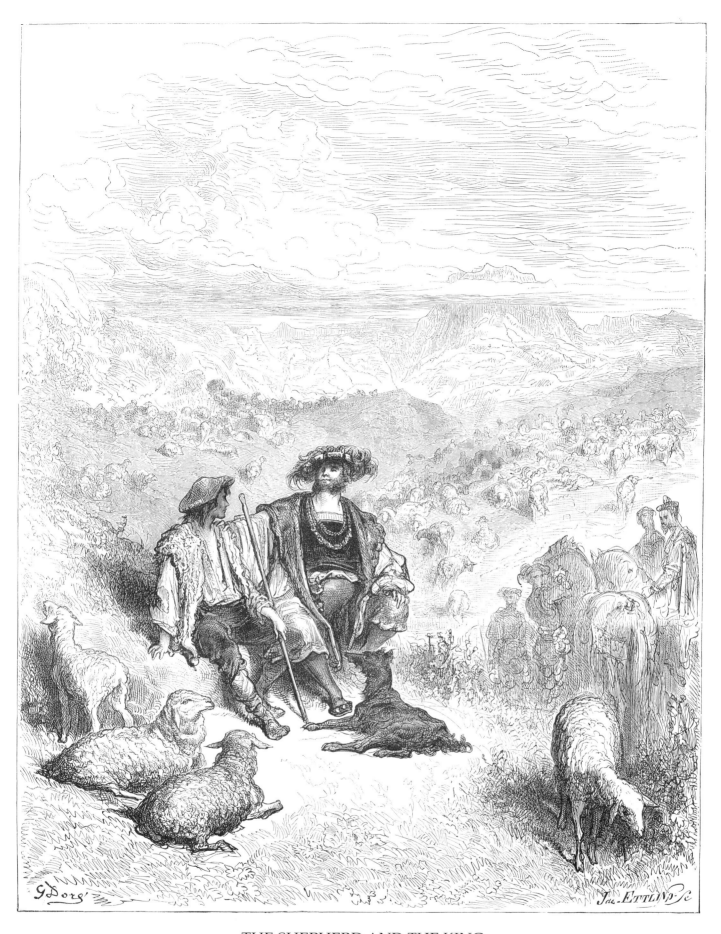

THE SHEPHERD AND THE KING
[Le Berger et le Roi]

The shepherd so impressed the king that he was sent to court;
his hermit friend warned him to reconsider.

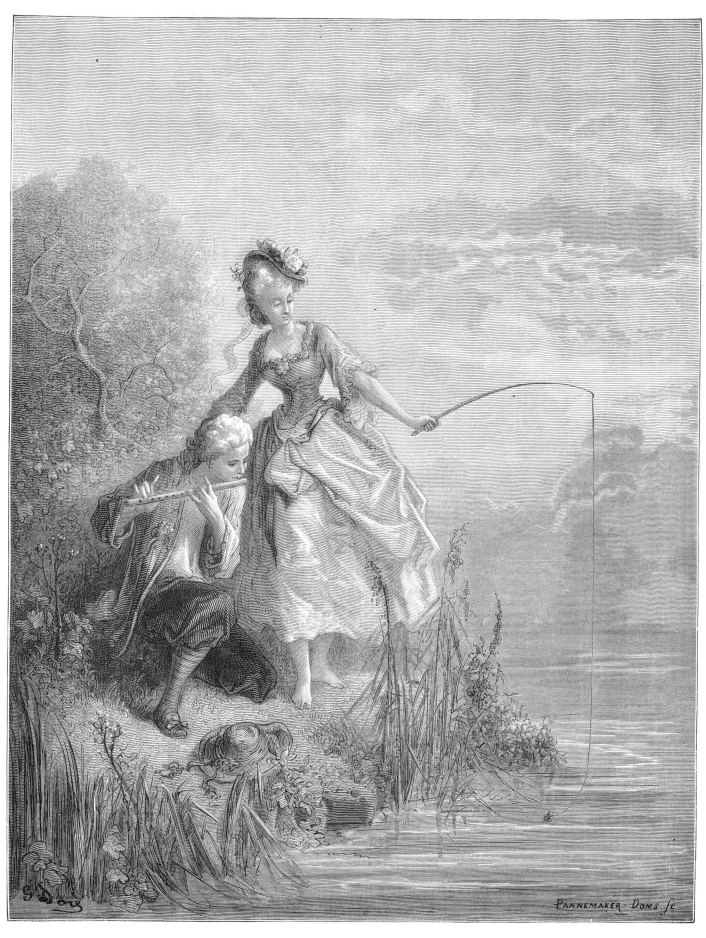

THE FISH AND THE SHEPHERD WHO PLAYED THE FLUTE
[Les Poissons et le Berger Qui Joue de la Flute]

The shepherd's coaxing tunes could not persuade the fish, but the net caught them easily.

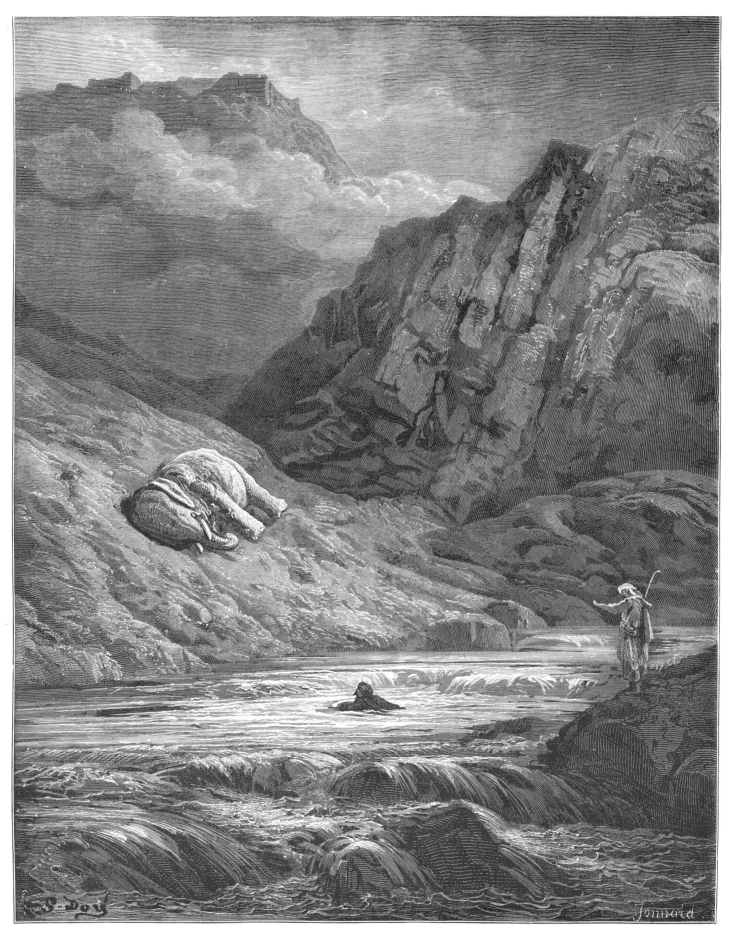

THE TWO ADVENTURERS AND THE TALISMAN
[Les Deux Aventuriers et le Talisman]

The one who risked his life was rewarded; the one who cautiously stood by gained nothing.

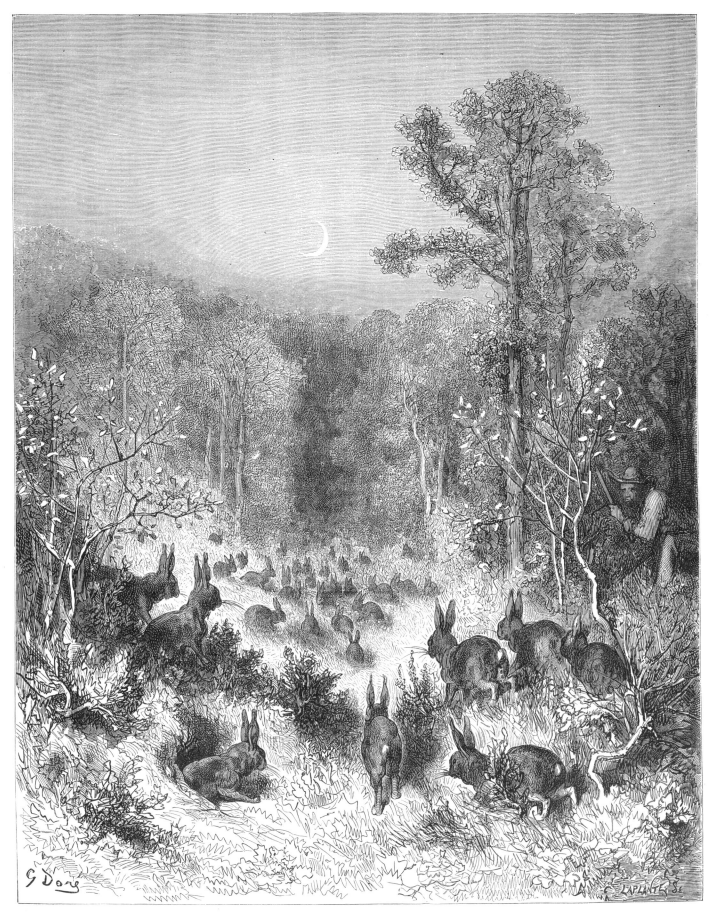

THE RABBITS
[Les Lapins]

Although they have been frightened, the rabbits risk their safety to venture forth once more.

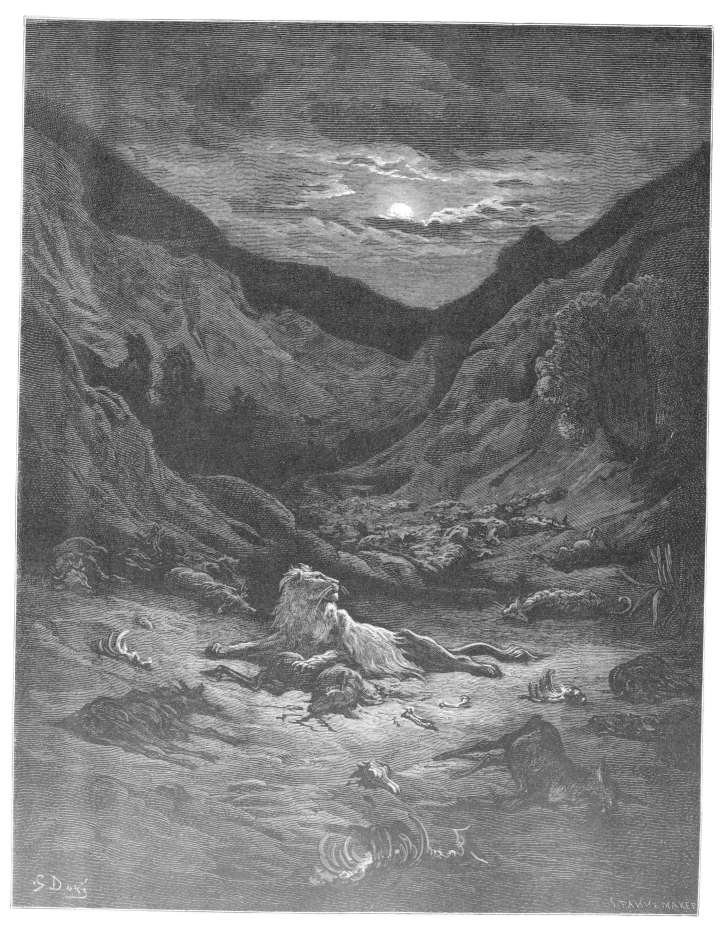

THE LION
[Le Lion]

The fox, sensing that the lion would one day be master, urged his friend
the leopard to get on the lion's good side.

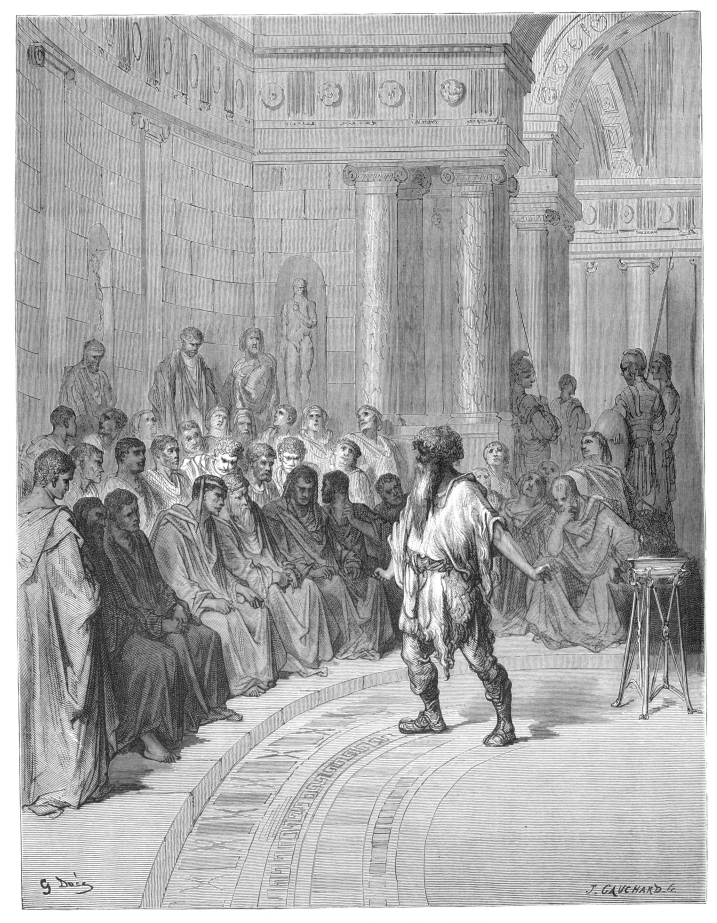

THE PEASANT FROM THE DANUBE
[Le Paysan du Danube]

Despite his savage appearance, the peasant won the day with his unexpectedly eloquent words.

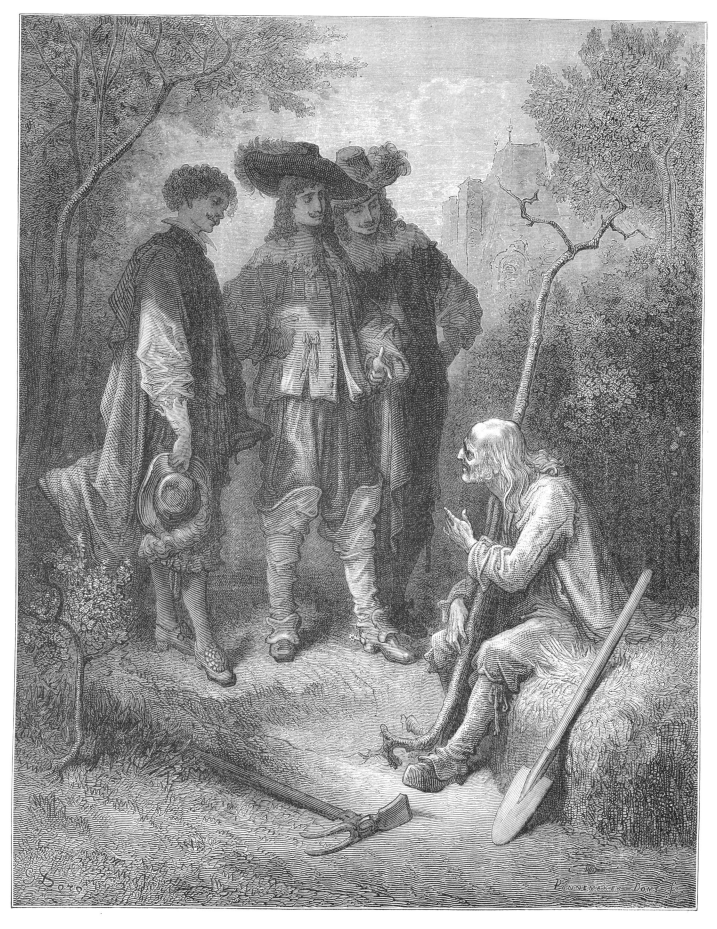

THE OLD MAN AND THE THREE YOUNG MEN
[Le Vieillard et les Trois Jeunes Hommes]

The youthful trio advised the old man not to plant his tree, thinking he would soon die;
he, however, outlived them, as they all met untimely deaths.

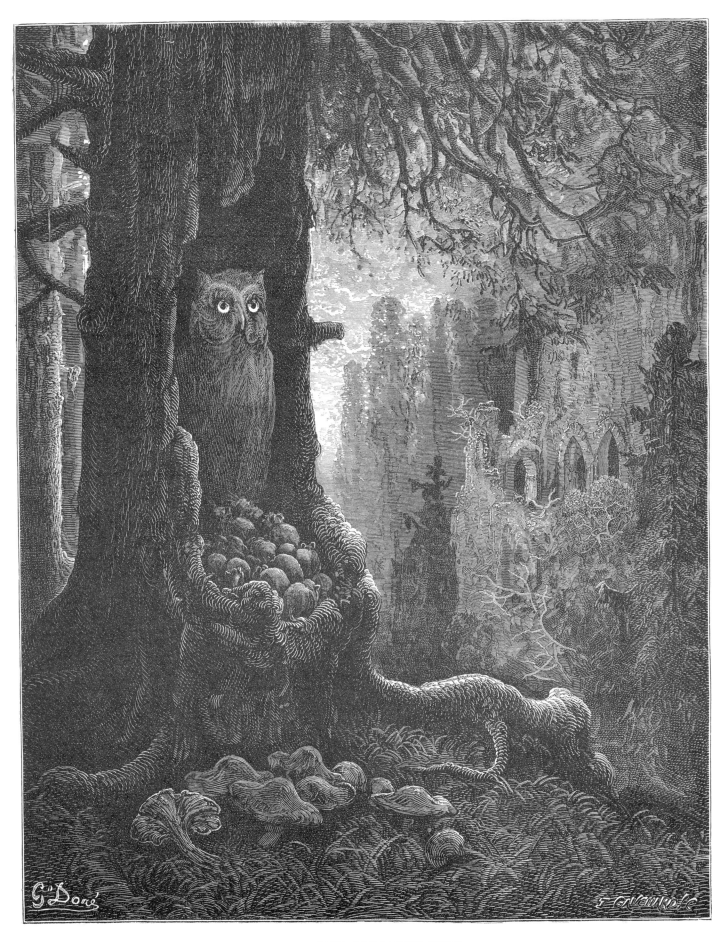

THE MICE AND THE OWL
[Les Souris et le Chat-Huant]

The owl found an ingenious way to keep a store of mice without killing them.

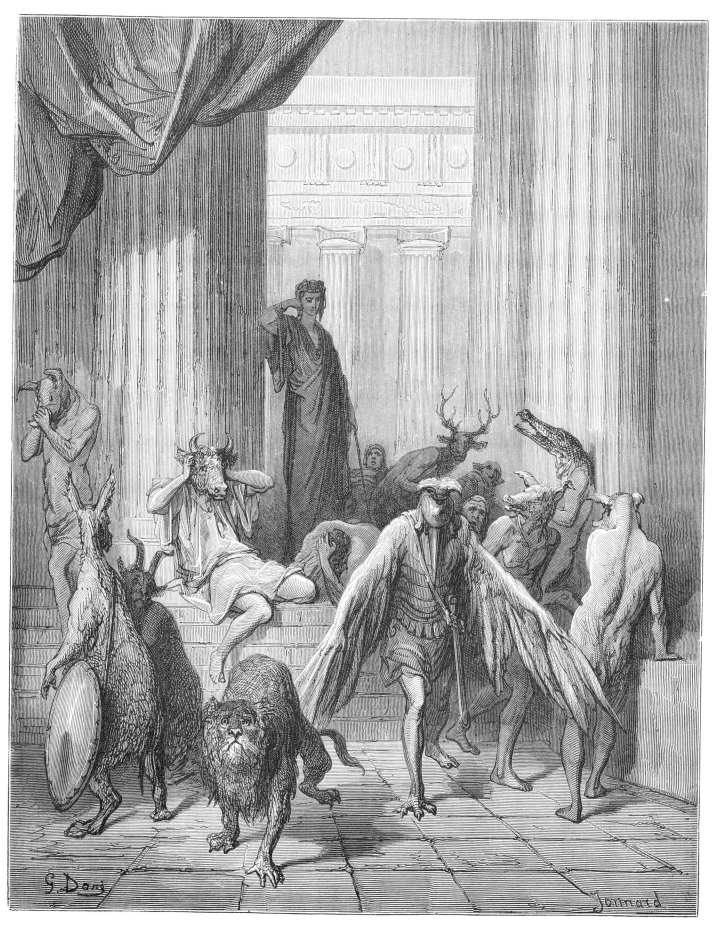

ULYSSES' COMPANIONS
[Les Compagnons d'Ulysse]

Ulysses offered his comrades a way to become men again, but they preferred their animal states.

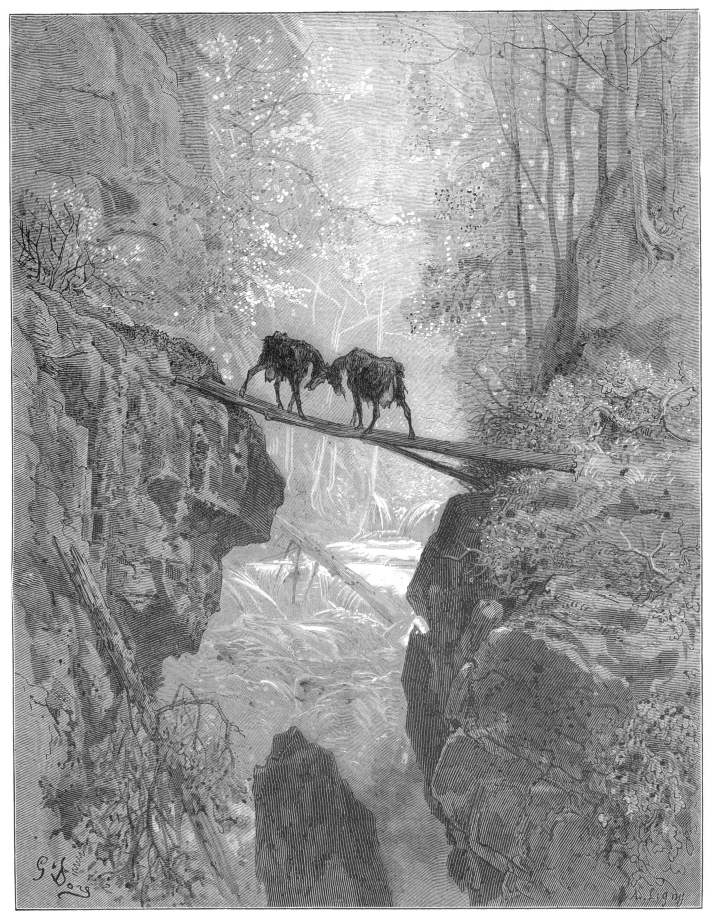

THE TWO GOATS
[Les Deux Chèvres]

Arriving at the same bridge, the two beasts refused to yield, and both perished.

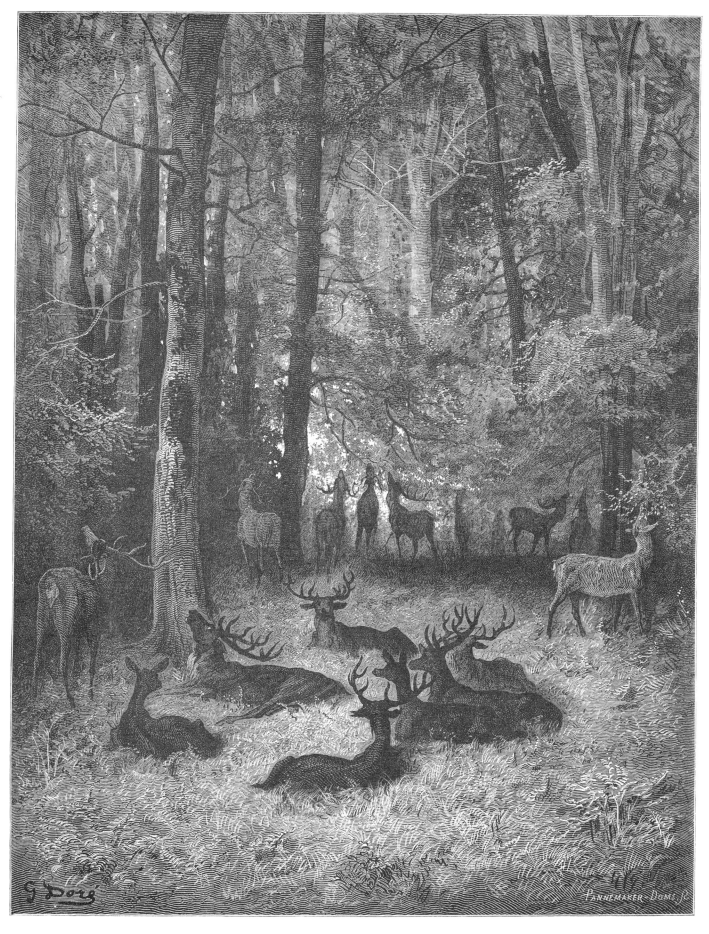

THE AILING STAG
[Le Cerf Malade]

Ostensibly lending support, the ailing stag's visitors ate his food, and he starved to death.

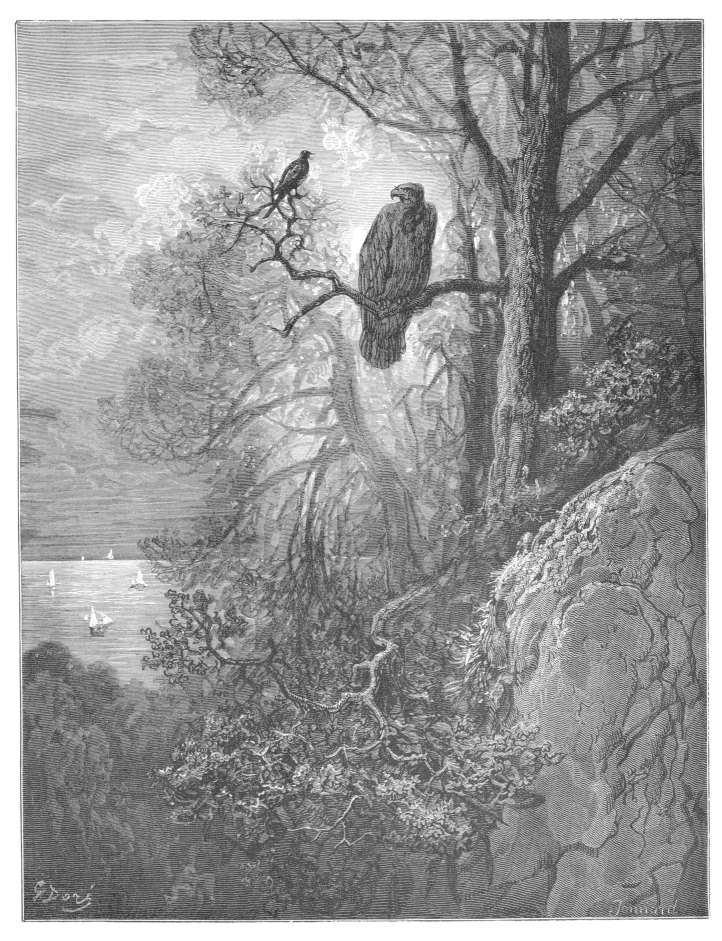

THE EAGLE AND THE MAGPIE
[L'Aigle et la Pie]

Queen eagle did not desire the discord that the magpie's spying would bring to her domain.

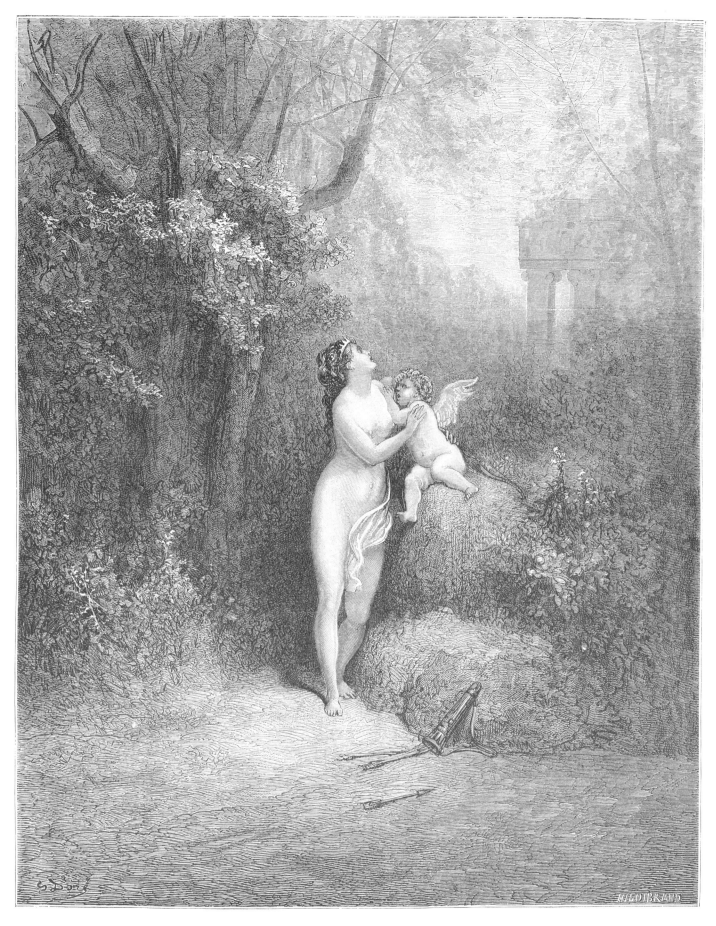

LOVE AND FOLLY
[L'Amour et la Folie]

Impatient Folly rashly blinded Love, and would forever more be required to lead him.

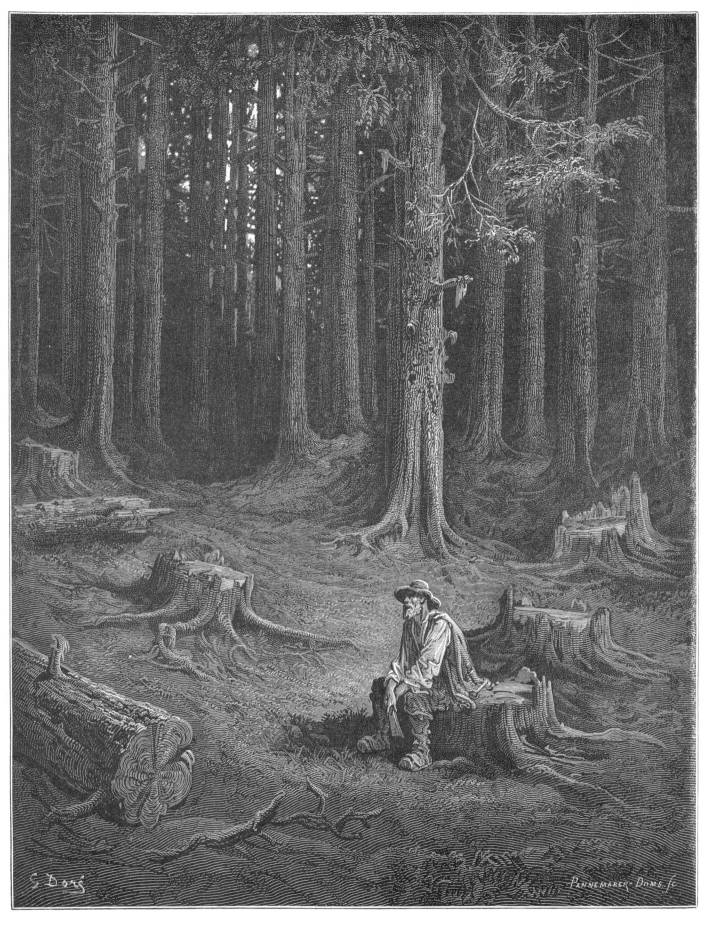

THE FOREST AND THE WOODMAN
[La Forêt et le Bucheron]

The woodman vowed to spare the bough; the forest believed him but was soon wounded with his axe.

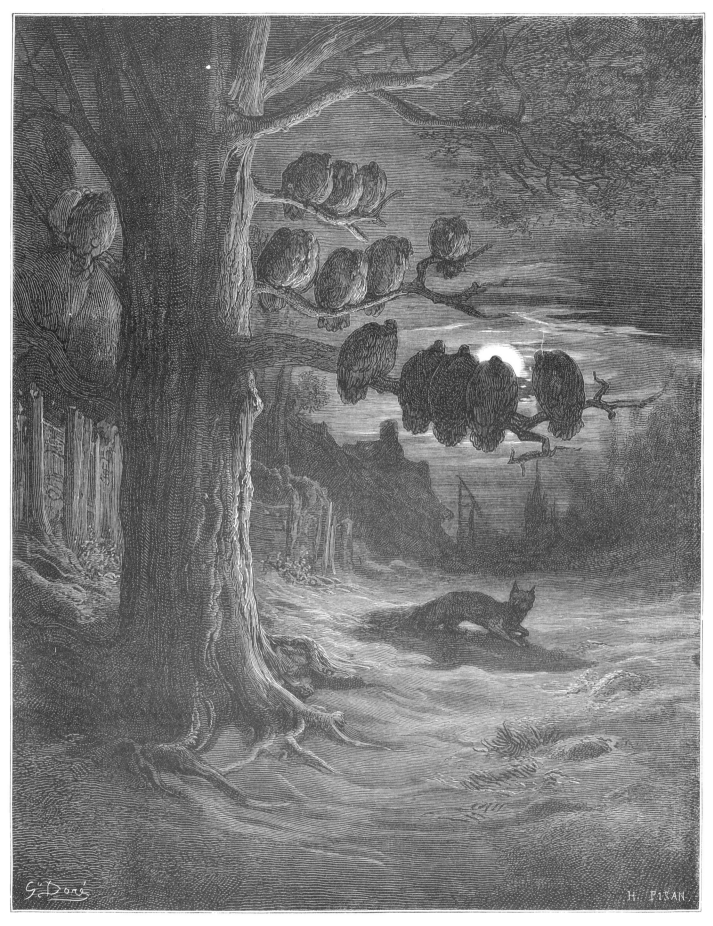

THE FOX AND THE HEN TURKEYS
[Le Renard et les Poulets d'Inde]

Distracted by the fox's trickery, the hen turkeys fell from their safe perch and were vanquished.

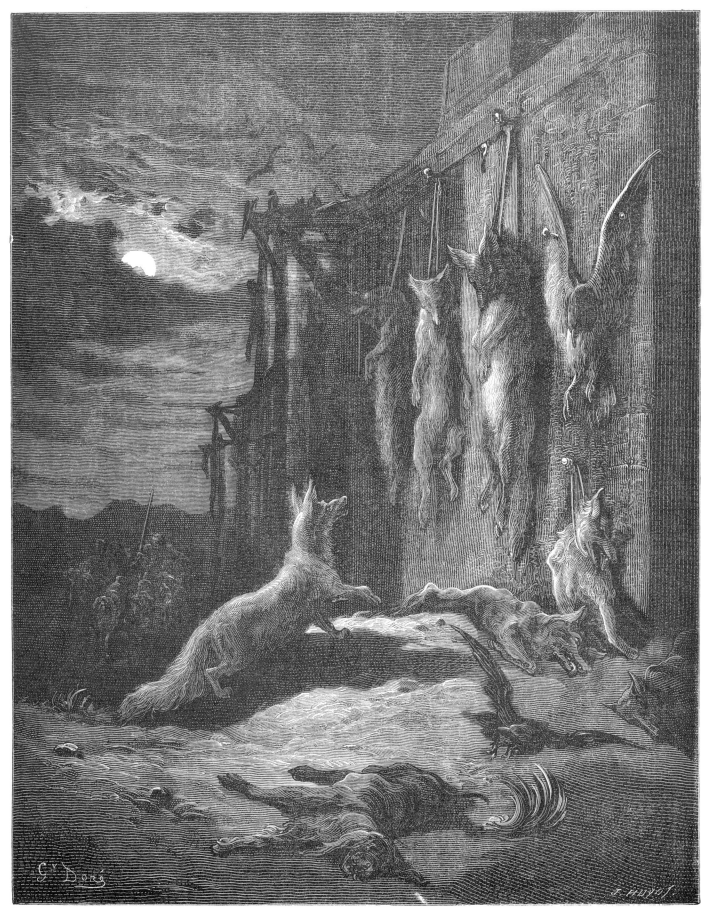

THE ENGLISH FOX
[Le Renard Anglois]

The fox saved his neck with a plan one day, but the ruse could not be used again.

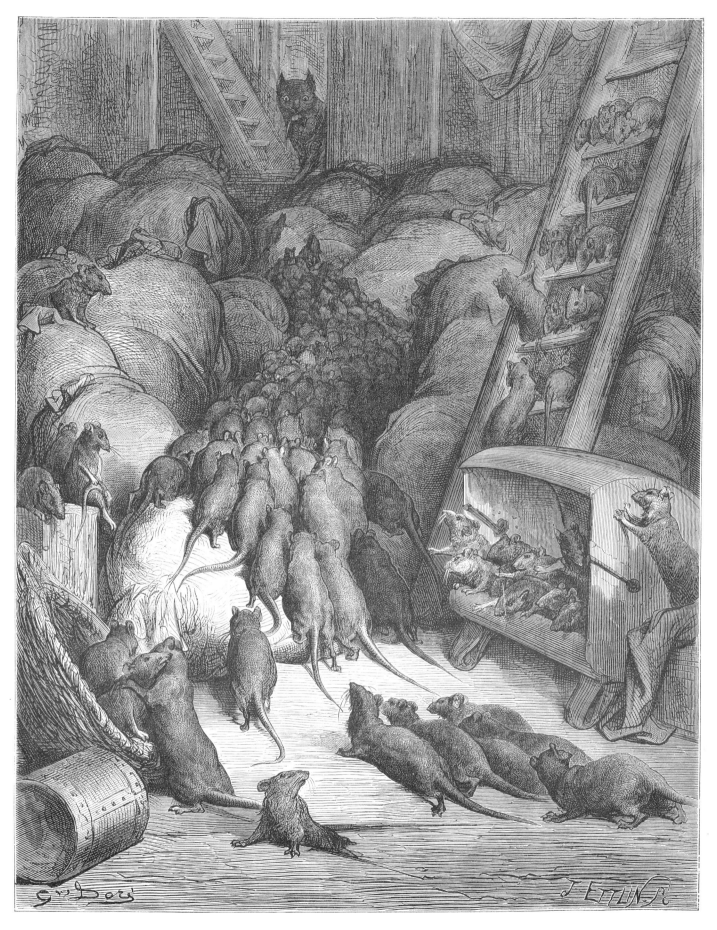

THE LEAGUE OF THE RATS
[La Ligue des Rats]

The rats' courage deserted them when they saw the ill-fated mouse.

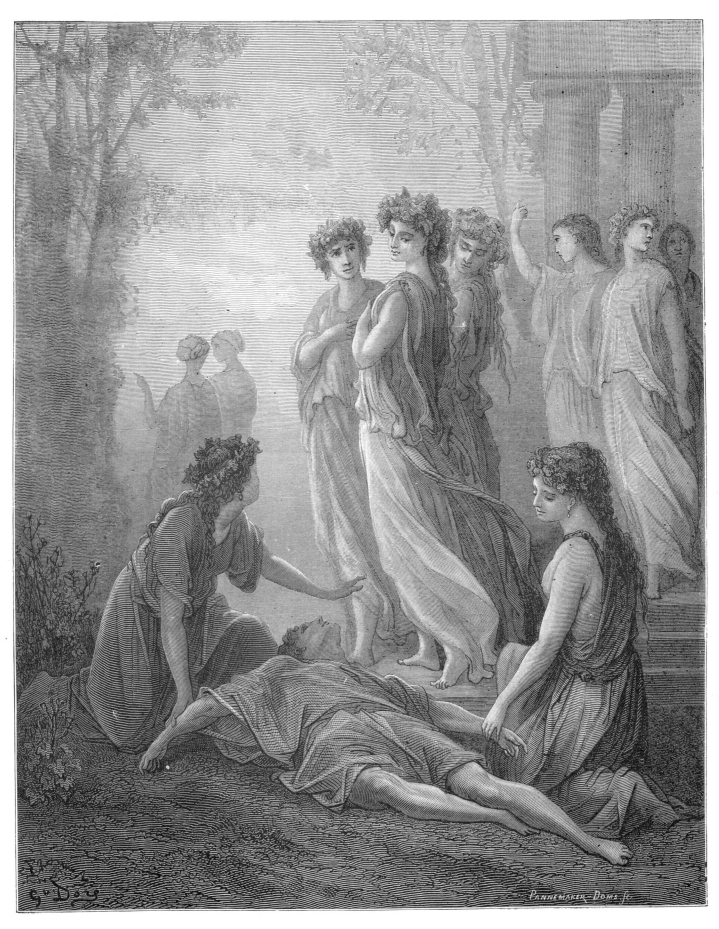

DAPHNIS AND ALCIMADURA
[Daphnis et Alcimadure]

Having caused Daphnis's death with her indifference, the
cruel Alcimadura was crushed by the youth's monument.

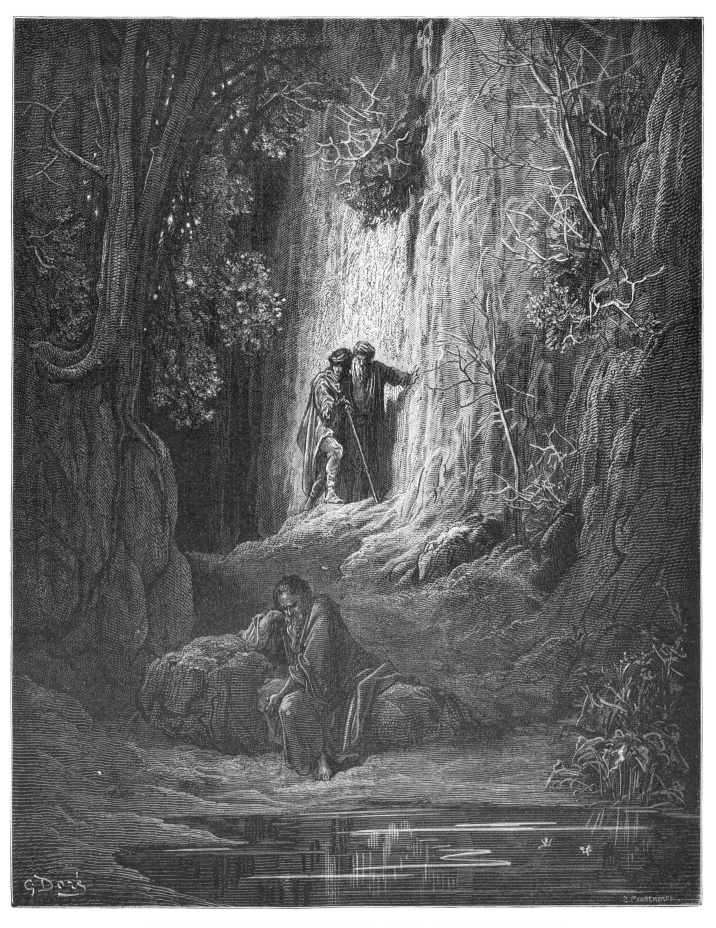

THE ARBITRATOR, THE ALMS-GIVER, AND THE HERMIT
[Le Juge Arbitre, l'Hospitalier et le Solitaire]

The hermit advised solitude as a means of gaining self-knowledge and quieting the din of the world.

VIGNETTES

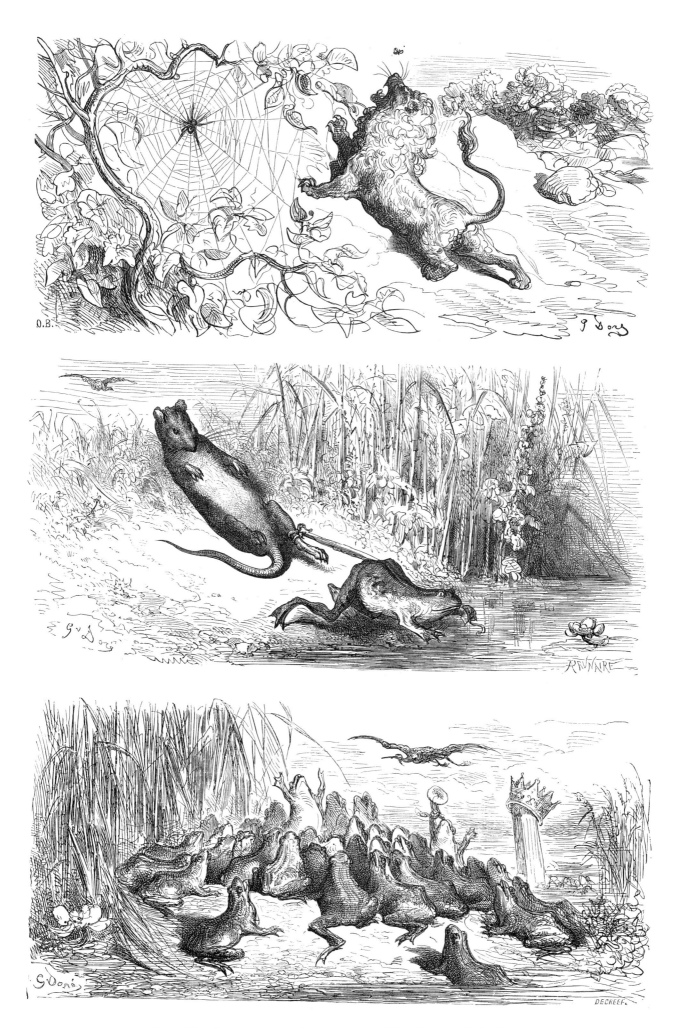

TOP: The Lion and the Gnat. CENTER: The Frog and the Rat.
BOTTOM: The Frogs Who Asked for a King.

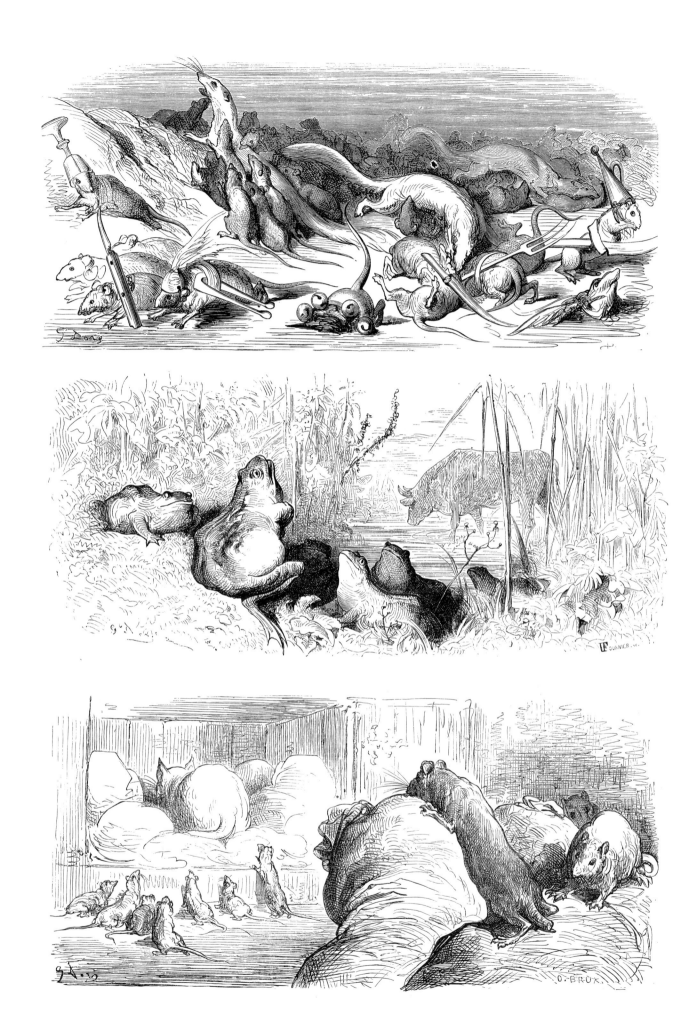

TOP: The War Between the Rats and the Weasels. CENTER: The Frog That Wanted
to Make Itself as Big as an Ox. BOTTOM: The Cat and the Old Rat.

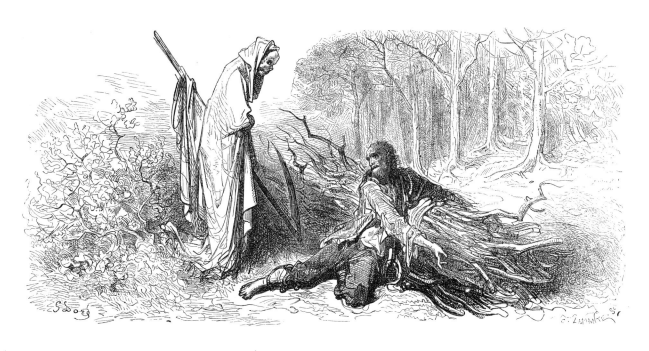

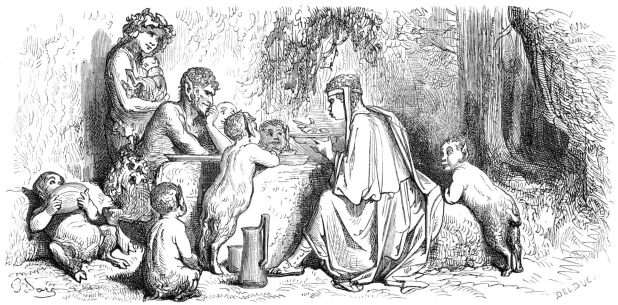

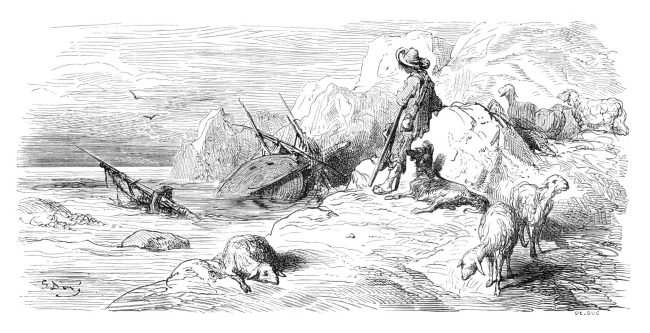

Top: Death and the Woodcutter. Center: The Satyr and the Passerby.
Bottom: The Shepherd and the Sea.

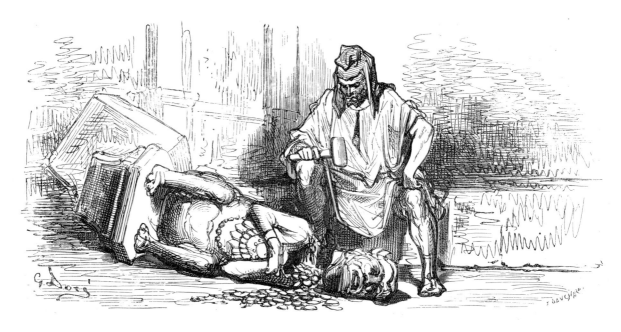

TOP: The Council Held by the Rats. CENTER: The Elderly Man and His Children.
BOTTOM: The Man and the Wooden Idol.

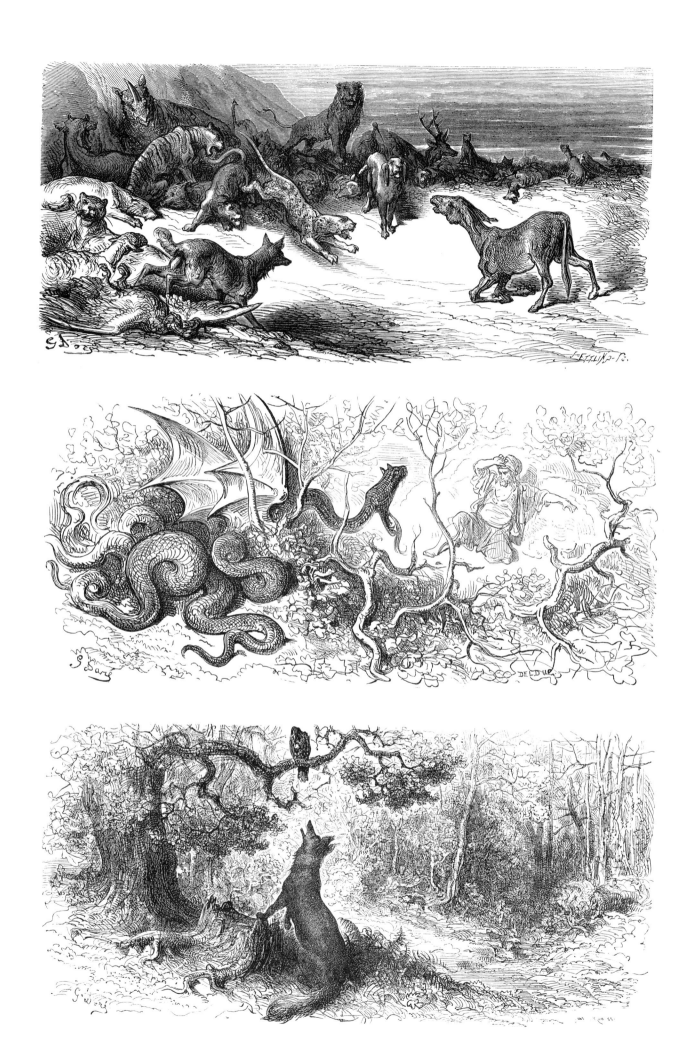

TOP: The Animals Sickened by the Plague. CENTER: The Dragon with Many Heads and the Dragon with Many Tails. BOTTOM: The Raven and the Fox.

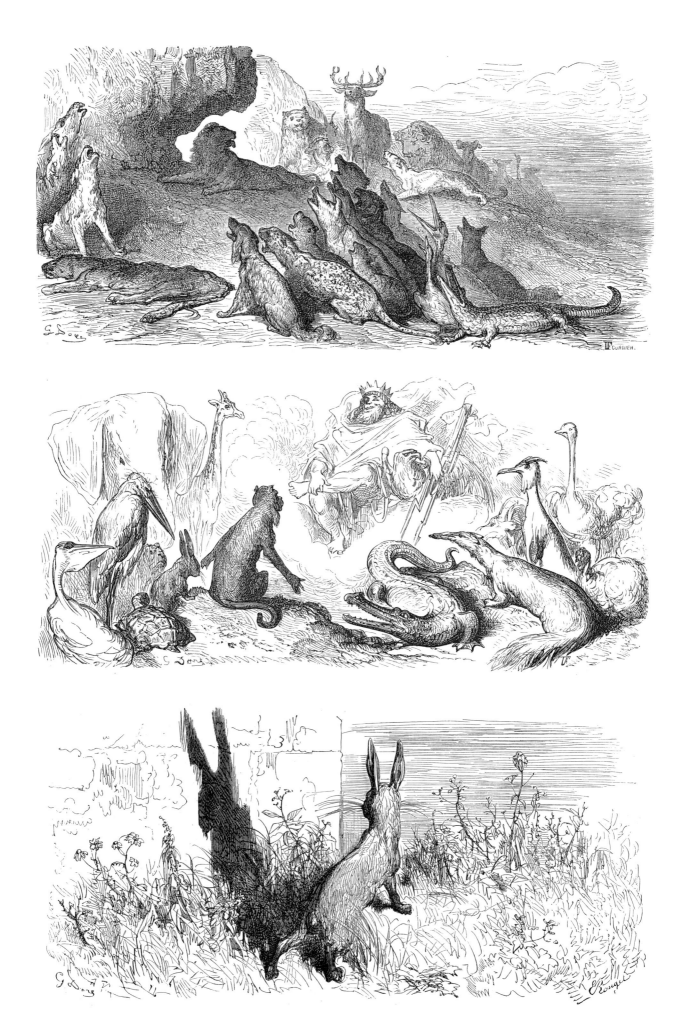

TOP: The Lioness's Funeral. CENTER: The Wallet.
BOTTOM: The Ears of the Hare.

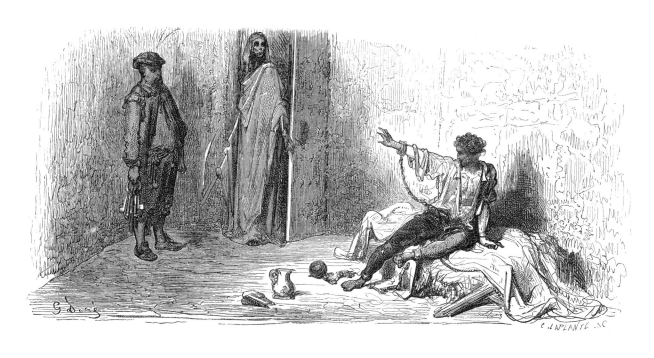

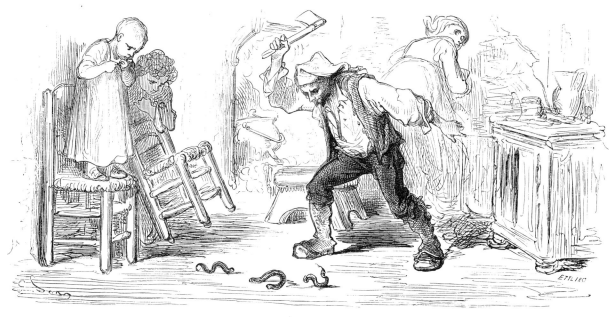

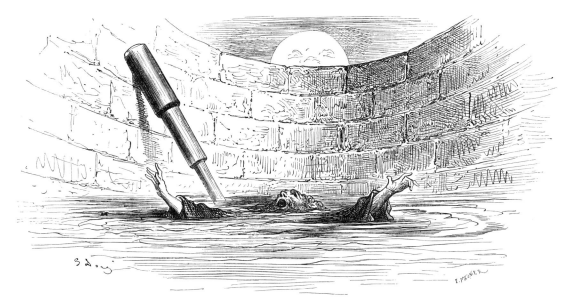

TOP: Death and the Malcontent. CENTER: The Peasant and the Snake.
BOTTOM: The Astrologer Who Fell into a Well.

93

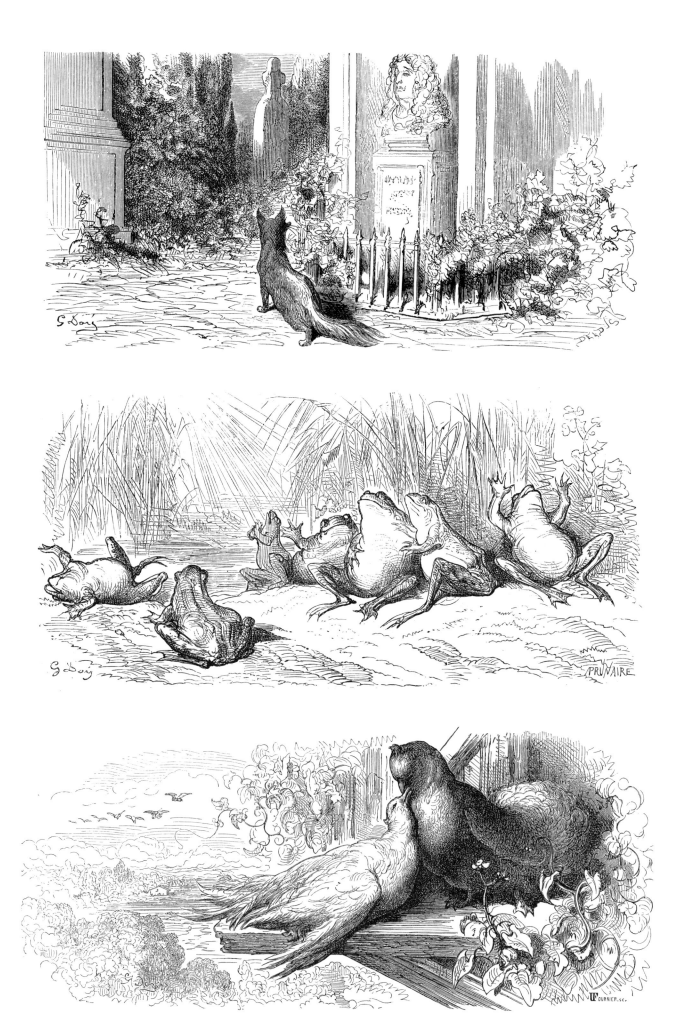

TOP: The Fox and the Bust. CENTER: The Sun and the Frogs.
BOTTOM: The Two Pigeons.

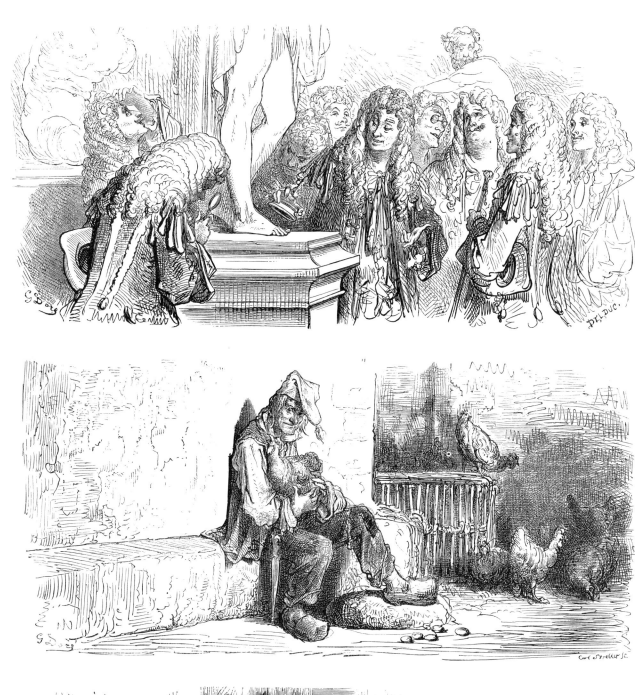

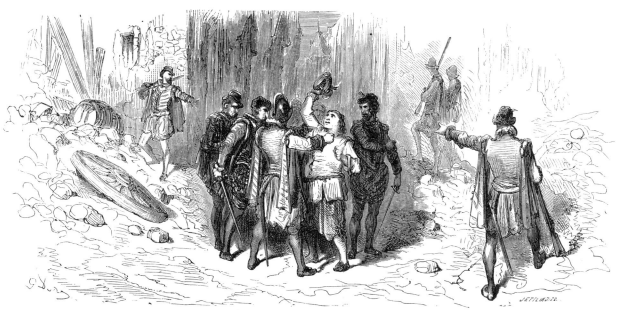

Top: Against Those Who Are Difficult to Please. Center: The Hen with Golden Eggs.
Bottom: The Bat and the Two Weasels.

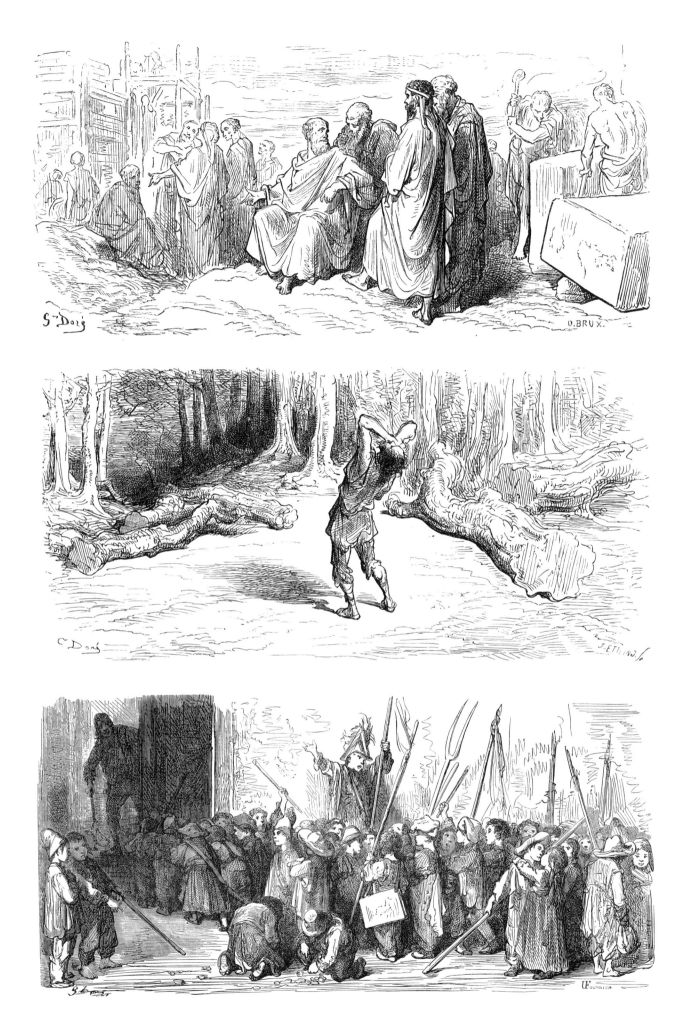

TOP: The Words of Socrates. CENTER: The Woodman and Mercury.
BOTTOM: The League of the Rats.

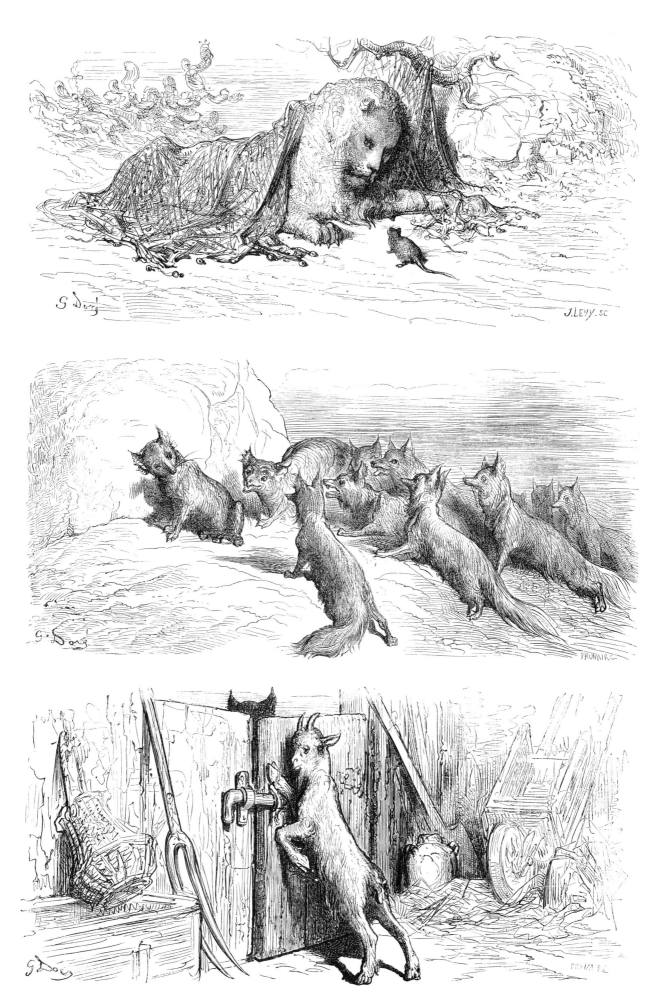

TOP: The Lion and the Rat. CENTER: The Fox with the Cropped Tail.
BOTTOM: The Wolf, the Goat, and the Kid.

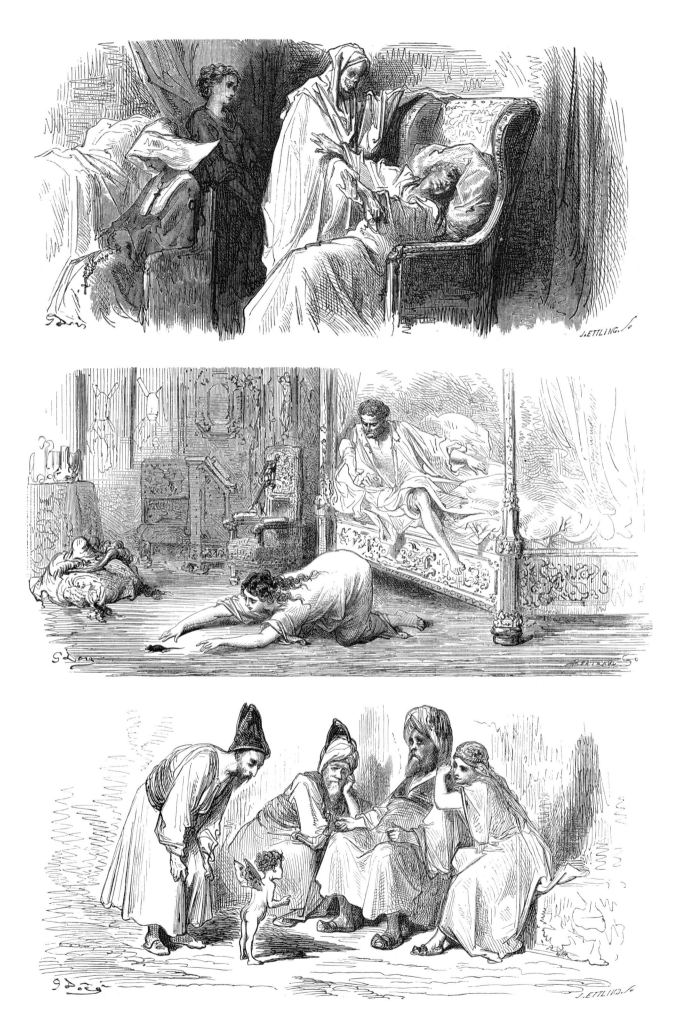

TOP: Death and the Dying Man. CENTER: The Cat That Changed into a Woman.
BOTTOM: The Wishes.

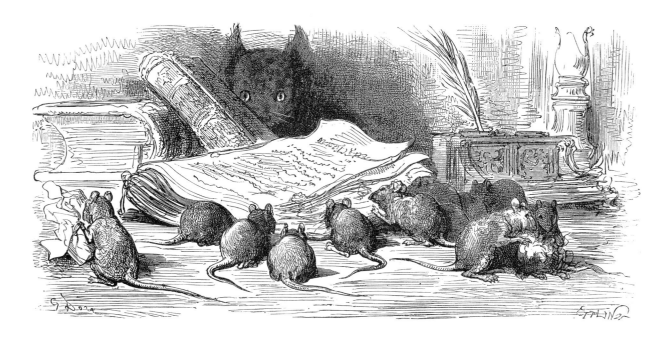

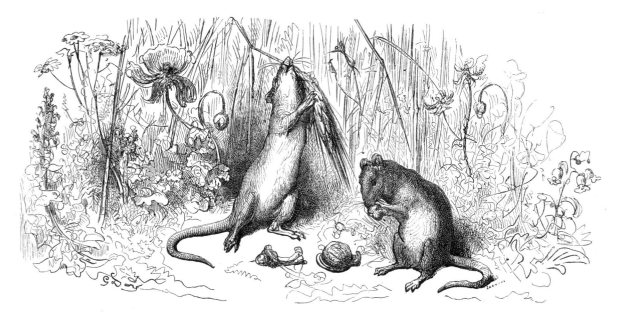

TOP: The Quarrel Between the Dogs and the Cats, and the Cats and the Mice.
CENTER: The Dog and Her Friend. BOTTOM: The City Rat and the Country Rat.